IMAGES
of America

SOUTH PASADENA

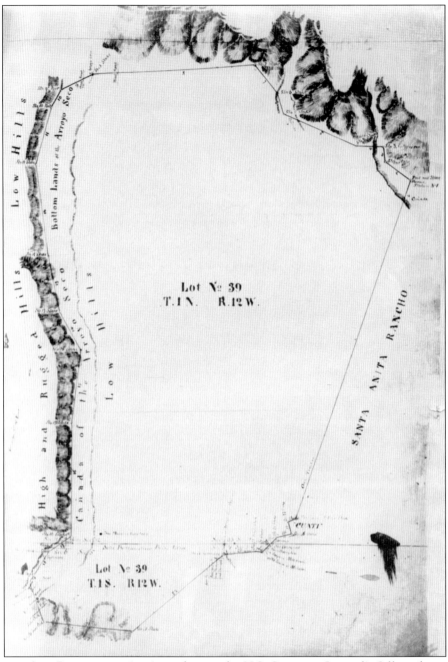

RANCHO SAN PASQUAL, 1858. According to the U.S. Surveyor General's Office, this record dated September 18, 1858, shows that the Rancho San Pasqual comprised 13,693 acres, covering much of present-day Pasadena, South Pasadena, San Marino, and Altadena. Manuel Garfias deeded the rancho to Benjamin D. Wilson on January 15, 1859, for the sum of $1,800 to help pay his mounting debts. (Courtesy Archives at the Pasadena Museum of History.)

ON THE COVER: Hotel guests pose for pictures behind the cactus garden at the renowned Raymond Hotel. (Author's collection.)

IMAGES of America
SOUTH PASADENA

Rick Thomas

Copyright © 2007 by Rick Thomas
ISBN 978-0-7385-4748-0

Published by Arcadia Publishing
Charleston SC, Chicago IL, Portsmouth NH, San Francisco CA

Printed in the United States of America

Library of Congress Catalog Card Number: 2007920160

For all general information contact Arcadia Publishing at: 2007920160
Telephone 843-853-2070
Fax 843-853-0044
E-mail sales@arcadiapublishing.com
For customer service and orders:
Toll-Free 1-888-313-2665

Visit us on the Internet at www.arcadiapublishing.com

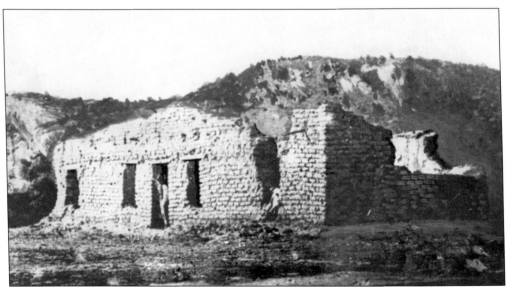

GARFIAS ADOBE AS IT APPEARED IN 1880. Manuel Garfias built a grand adobe hacienda that Benjamin S. Eaton described as one of the finest country homes in Southern California. This historic site was also where the first child of non-native parents was born in what is now South Pasadena. Today, on the nearby banks of the Arroyo Seco, water still flows from the spring that bears his name. (Courtesy Archives at the Pasadena Museum of History.)

Contents

Acknowledgments		6
Introduction		7
1.	Scent of a City	9
2.	The Raymond	19
3.	Cawston Ostrich Farm	31
4.	City of Trees	41
5.	Tragedy Strikes Home	49
6.	The Fight	57
7.	The Power of Dreams	71
8.	Small-Town Charm, Big-City Heart	93
9.	Our Town	105
10.	South Pas at Nightfall	117

ACKNOWLEDGMENTS

So many people helped me in preparing this book. I'd like to mention a few locals here: Glen Duncan; Police Chief Dan Watson; Norma Le Valley; Henk Friezer; South Pasadena Public Library; Richard Beebe; Mike Shea; Steve Fjeldsted; and the Archives at the Pasadena Museum of History, Laura Verlaque, and Kirk Myers.

A special thanks to Jane Apostol for her wonderful book, *South Pasadena: A Centennial History* (1987), and my daughter Lauren Thomas, who was the photographer on this project. Most of the historical photographs in this book are from my personal collection.

For the remainder of this section, I'd like to acknowledge and thank the people of South Pasadena. Without their enthusiasm and creative spirit, this book would not be possible. For a community to thrive, it takes the volunteer efforts of city commissioners, service clubs, business organizations, and preservation groups. In this regard, our small city has been blessed. There has never been a shortage of volunteers willing to step up and help neighbors.

South Pasadena's success can also be attributed to the dedicated men and women of the fire and police departments, school district, and public library. The less glamorous and often unrecognized city departments—the planning department and public works department—also play critically important roles in maintaining our city's small-town appearance. Our city's churches have supported our community in times of jubilation and great sorrow. And since the beginning, our city has had a newspaper, known initially as the *South Pasadenan* and in recent decades as the *South Pasadena Review*, which has been on the scene, faithfully reporting our city's news stories.

South Pasadena residents have always supported our country in times of crises and war. We owe a great debt to the brave men and women currently serving in the armed forces, the veterans who served our country so faithfully, and those who made the ultimate sacrifice so we may enjoy our freedom and the blessings of liberty.

We are quite fortunate to have been born during a time of booming technology and convenience, to live in the greatest nation ever known, and to raise our children and live in the best community on earth.

INTRODUCTION

The year was 1892. They traveled for days by train across the deserts and Rocky Mountains confined to their opulent Pullman Palace Cars, forever in sickening motion. They saw nothing but what they considered wasteland from their wood-framed motion picture–like window views. The place was void of man-made structures of any kind. Nothing was there to remind them of the civilization they left behind. Fortunately, they had the train. It would be their refuge on wheels while passing through inhospitable lands on their journey to what must have felt like the far reaches of the earth—the West.

The scenery went on like this until the sun finally melted on the horizon into a curious blend of rippled marmalade orange and stark adobe red. Only as the massive iron steamer made its long slow turn to transverse higher elevations could they make out the perfectly uniform rails that lay parallel up ahead. These, too, seemed to vanish into nothingness.

Then it happened. The sword-like quills of the yucca gave way to the ogre-like twisted arms and gnarled skin of the giant oak. This meant that their winter home was near. Their destination was the Raymond Hotel, which was situated on a hilltop that overlooked the small city of South Pasadena.

The mighty locomotive approached from the south, belching an enormous column of soot that rose into the pristine pale-blue sky. The arduous journey was about to end. The "Royal Raymond" was clearly in view now. The famed resort hotel was most definitely an impressive sight. Its stately Empire-style all-wood structure had dozens of brick chimney stacks poking up like fingers through its distinctive mansard roof. The Raymond stood on the hill at full attention yet customarily aloof on this occasion because, as with prior California-bound tour groups hosted by Raymond and Whitcomb, inexplicably the steadfast locomotive pulled up lame. It chugged one stroke slower with each tic of the conductor's pocket watch. The train jolted to a full stop, then sat on the tracks hissing steam. Half a dozen bellmen leaped from the forward railcars and ran back to help passengers step down from the train.

The noonday sun immediately brightened their pale faces. The Center Street School bell could be heard clanging nearby. The Wynyate mansion was the only visible structure on a nearby grassy hillside—their only proof of the charming city they were told had fewer residents than the number of hotel guests at the Raymond.

Even before stepping on the rich soil, they were met with a strange odor. The same vague scent was noticed shortly after crossing the trestle that stretched across the Arroyo Seco at Garvanza. As they stepped away from the Salt Lake Railroad tracks, the fragrant scent of orange blossoms was everywhere.

The weary travelers disappeared into the orchards with a professional photographer in tow. Stunning, they thought. Rising high above the orange-spotted, dense-leafed trees was a truly magnificent sight—"Behold," God seemed to be saying, "I give you the Sierra Madres." Before them was a breathtaking range of rugged, snowcapped mountains. A small city was tucked away just beyond the orange grove. Thousands of pure-white blossoms dotted the trees like large

snowflakes. It was winter, but the sun was warm and the perfume of spring was definitely in the air. The Raymond party rose to their feet in silent awe of this place. They had arrived safely at their destination.

They were in South Pasadena.

Today South Pasadena's small-town charm harkens back to its early days. Still visible are the Sierra Madres, which are known today as the San Gabriel Mountains. But there are many other changes indicative of the region's rapid population growth since the late 1800s. The historic Arroyo Seco Parkway today follows the same right-of-way that the mighty steamer once did through South Pasadena. The grand hotel on the hill, the Raymond, burned down on Easter Sunday, 1895, and was rebuilt in 1901 to see its heyday years in the second and third decades of the 20th century, only to be razed soon after the Great Depression. The hill is now covered with apartment buildings. The orange groves are all gone, and so is the scent of the city. What has remained is the people's indomitable spirit and sense of community.

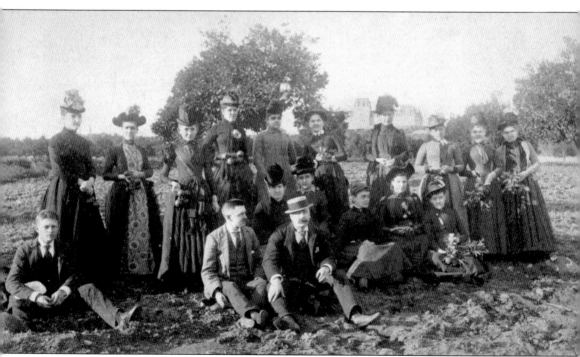

SOUTH PASADENA ORANGE GROVE, 1892. Guests of the Raymond hold branches of oranges and blossoms while posing for a professional photographer from the Jarvis Studios. Faintly seen in the photograph is the washed-out image of the Raymond just to the right of the large orange tree behind the party.

One
SCENT OF A CITY

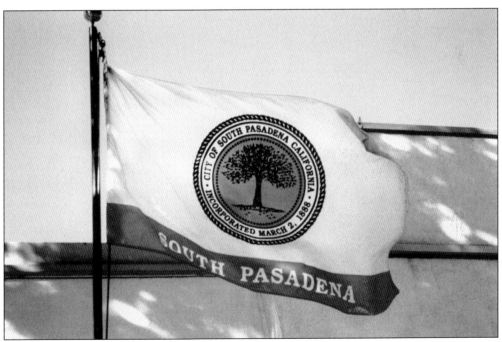

SOUTH PASADENA SEAL AND FLAG. The city seal that appears on the flag shows the image of a tree. The former city seal, in mosaic on the South Pasadena Public Works Building at 825 Mission Street, shows the tree symbol as an orange tree. Newspaper articles and city documents also identify the orange tree as the tree of the city's seal. The seal has been redrawn in its present-day incarnation to appear as a generic tree-city symbol.

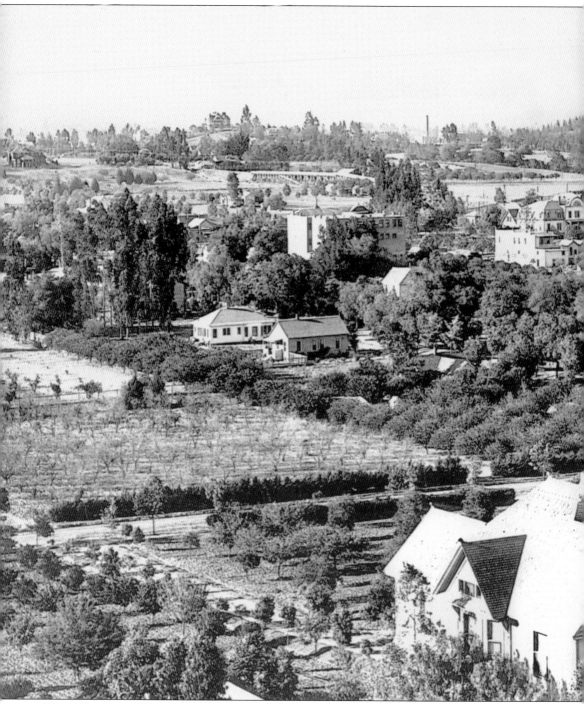

SOUTH PASADENA VIEWED FROM MONTEREY HILLS. Several prominent fruit growers and industry leaders made South Pasadena their home. Andrew O. Porter served as chairman of the newly formed San Gabriel Orange Grove Association in 1873. He played a key role in the success of the region's first orange-grower cooperative. The Porter family remained active for generations in helping to shape South Pasadena into the thriving community it is today. In later years, the

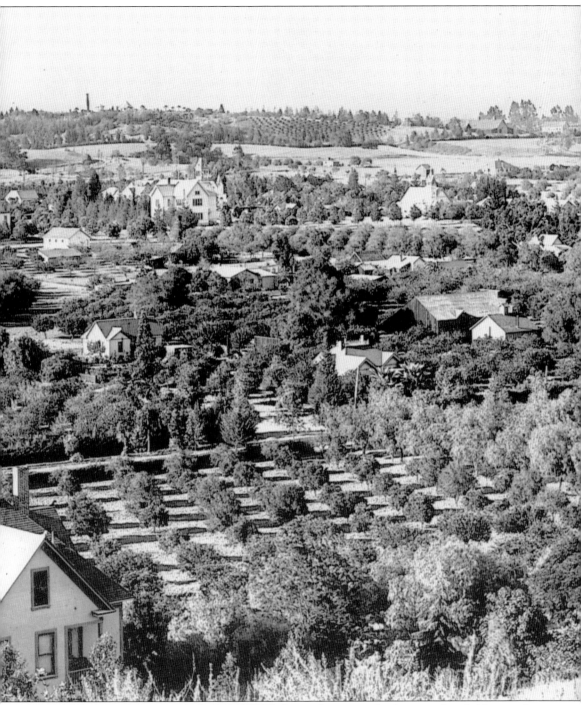

California Fruit Growers Exchange (CFGE), better known as Sunkist, was headed by another South Pasadena resident, G. Harold Powell. In 1921, the Sunkist cooperative sold over $121 million worth of citrus fruit to the wholesale trade. The Porter and Powell residences are still standing on Orange Grove Avenue and Marengo Avenue respectively. Here Monterey Road is seen in the foreground.

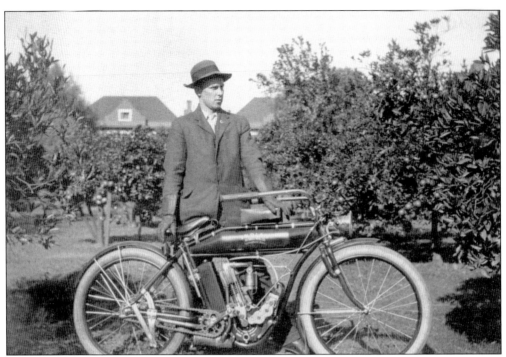

CARL AND HIS INDIAN, 1911. Local motorcycle enthusiast Carl Marsh takes a rest stop with his Indian motorcycle before joining a motorcycle rally at Raymond Avenue and Green Street in Pasadena.

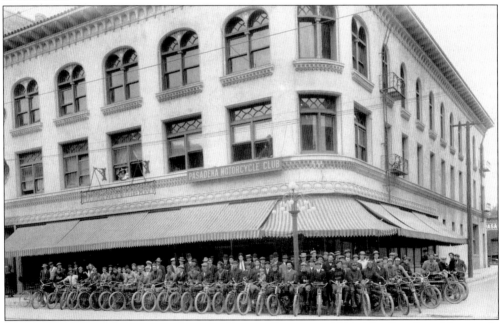

MOTORCYCLE RALLY THROUGH ORANGE GROVE COUNTRY, 1911. The Pasadena Motorcycle Club gathered on April 28, 1911, to ride through orange groves to Ventura and back. The distance traveled was 163 miles and took eight hours and five minutes to accomplish. (Courtesy Archives at the Pasadena Museum of History.)

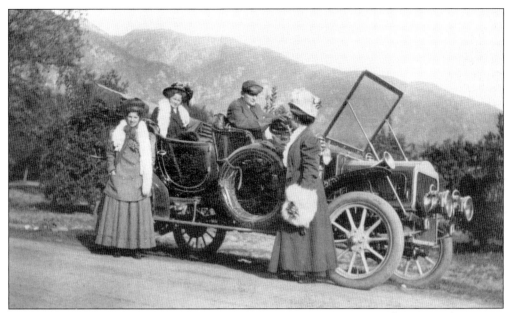

ORANGE BLOSSOMS' "HEAVY SWEET PERFUME." Vacationing motorists often stopped at orange groves to enjoy picking fruit and posing for pictures. One tourist brochure described the experience of driving from the Raymond Hotel on a day trip as "endless groves of orange trees laden with golden fruit" through "wave after wave of heavy sweet perfume."

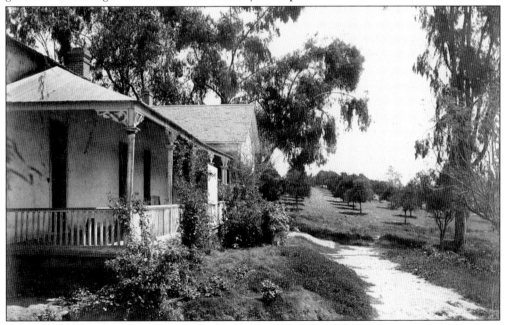

ORANGE GROVES SURROUND THE ADOBE FLORES, 1887. In 1847, Mexican general Jose Flores withdrew to a camp on Raymond Hill in present-day South Pasadena after his Californios skirmished with a U.S. Army detachment near Los Angeles. On the evening of January 9, 1847, Flores met with his advisors, who included Manuel Garfias, to draw up surrender plans to the United States, ending the Mexican colonial period in California. (Courtesy Archives at the Pasadena Museum of History.)

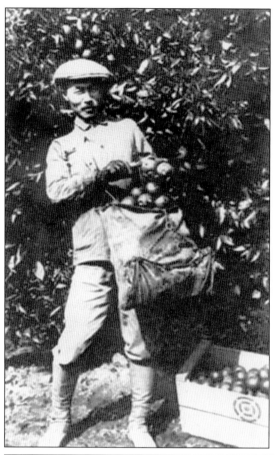

AHN CHANG HO, 1910. In a nearby Southern California orange grove, picker Dosan Ahn Chang Ho organized fellow Korean workers to improve production on C. E. Rumsey's Alta Cresta Groves in exchange for steady employment and better working conditions. These skills would later serve him as spiritual leader of the Korean Independence Movement. Dosan utilized many of G. Harold Powell's breakthrough orange-picking techniques to help reduce produce loss and premature spoilage. (Courtesy Los Angeles Public Library.)

ORANGE GROVES AT THE COLORADO STREET BRIDGE. Orange groves once filled the Arroyo Seco from Devil's Gate to South Pasadena.

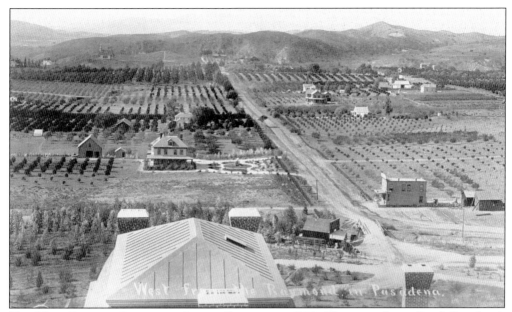

THE NEW ORANGE GROVES OF SOUTH PASADENA, 1892. This view shows South Pasadena's new orange groves from the very highest point on Raymond Hill. Imagine being transported back through time over 100 years to the rooftop of the Raymond Hotel, looking down at Columbia Street with the Arroyo Seco in the distance.

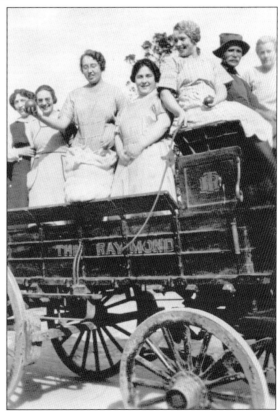

DAY TRIPPING IN ORANGE LAND, 1902. Jubilant guests of the Raymond return from the local groves weighed down with their haul of oranges.

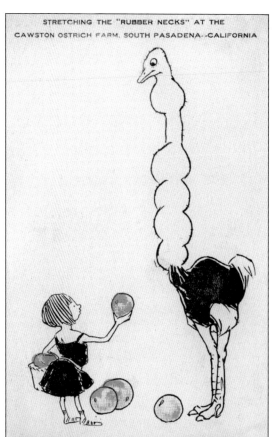

STRETCHING NECKS AT THE OSTRICH FARM, 1912. This comical postcard shows the odd sight of whole oranges being fed to an ostrich at the Cawston Ostrich Farm. Local orange growers supplied South Pasadena's world-famous ostrich farm with this very plentiful and unusual bird feed.

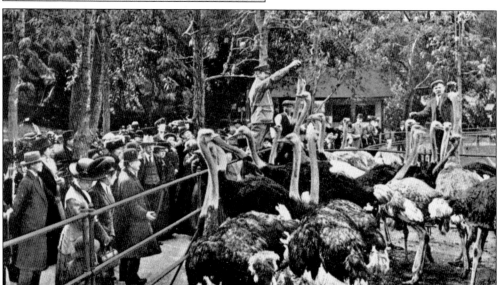

THE OSTRICH FEEDINGS, 1915. Visitors to the Cawston Ostrich Farm watched as attendants dropped unpeeled oranges to the ostriches from their outstretched arms. Large crowds would gather to witness the spectacle of these feedings. They relished the odd sight of several baseball-sized lumps moving slowly down the ostriches' slender, snake-like necks.

THE SUBJECT WAS ORANGES IN SOUTH PASADENA. A variety of photographs were taken of East Coast tourists picking oranges in the orchards, filling their hats with oranges, and smiling broadly—mostly because they knew their buddies were buried knee-deep in snow. The photograph at right was taken at a professional photography studio with the popular caption, "I'll eat oranges for you. You throw snowballs for me."

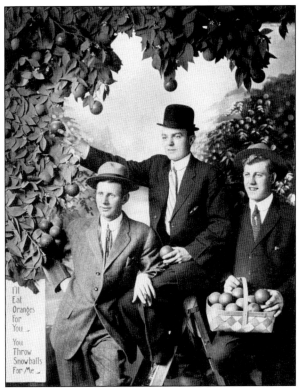

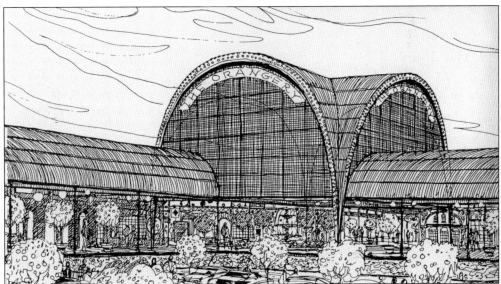

THE ORANGERY SHOPPING CENTER, 1974. Taking advantage of South Pasadena's popular orange heritage, a four-block downtown revitalization project called the Orangery Shopping Center was proposed. The Orangery was a wooden-lattice superstructure covering a variety of boutique businesses in a mall-like setting infused with dozens of orange trees. City council approved construction of the project, and a ground-breaking ceremony took place in November 1977. The city and local merchants squabbled over final plans, and construction never got off the ground. (Courtesy South Pasadena Public Library.)

SOUTH PAS ORANGE TREE LOGO, 1963. A resurgence of interest in the city's orange heritage occurred when South Pasadena celebrated its 75th-anniversary Diamond Jubilee.

THE ORANGE BLOSSOM. For more than 110 years, South Pasadena had as its official city flower an enduring symbol of its rich orange heritage, the orange blossom. In 2002, during a late-night voice vote by city council, the orange blossom was replaced with the tiger lily. One council member proposed the change, claiming the tiger lily was more desirable because it was a more substantial non-tree flower that referred to the high school mascot, Timothy Tiger.

Two

THE RAYMOND

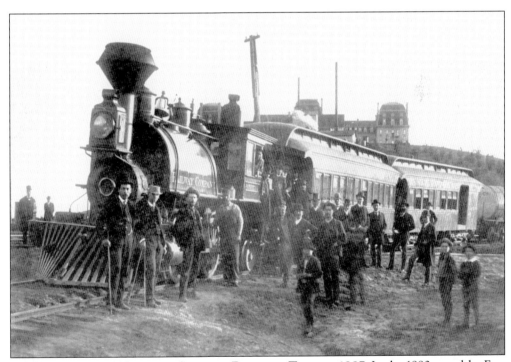

PASADENA RAILWAY COMPANY STEAMER RESTS ON TRACKS, 1887. In the 1880s, wealthy East Coast visitors stayed at the Raymond in South Pasadena, mostly to escape the harsh winters. Some people had health problems and came for a warm, dry climate to heal or fight off a life-threatening disease. Several aging Civil War veterans came in search of new opportunities. Others came to South Pasadena merely for the adventure. (Courtesy Archives at the Pasadena Museum of History.)

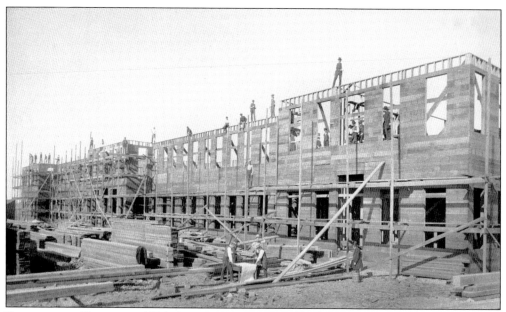

BUILDING THE RAYMOND, 1886. An enormous amount of lumber was required for the construction of a resort hotel of this magnitude. Thousands of wooden boards and massive support beams were stacked up high on the graded hilltop. The Raymond was considered a high-risk venture. A fallen oil lamp or a single glowing ember from one of its two dozen chimneys could render this sizeable investment a total loss in about 30 minutes. (Courtesy Archives at the Pasadena Museum of History.)

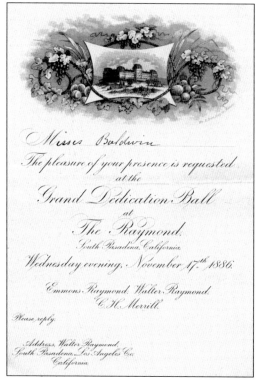

INVITATION FOR GRAND DEDICATION BALL, 1886. This formal invitation was received by the Baldwins to attend the Grand Dedication Ball at the Raymond in South Pasadena for the evening of November 17, 1886.

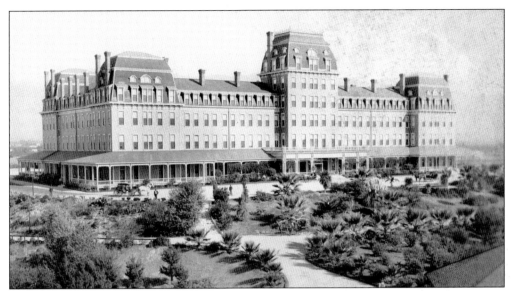

"The Royal Raymond" of South Pasadena, 1987. This spectacular 200-room resort hotel dominated the landscape for miles in all directions and gave its village-like host city of South Pasadena a sense of pride that continues to this day.

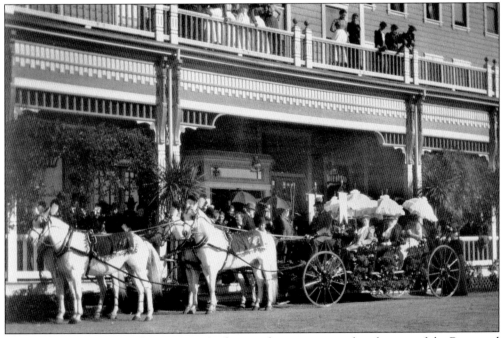

Tournament of Roses Day, 1892. At the grand entrance, privileged guests of the Raymond depart in a rose-laden tallyho to ride in the newly formed parade hosted by the Valley Hunt Club. Prof. C. F. Holder addressed club members: "In New York, people are buried in snow. Here our flowers are blooming and our oranges are about to bear. Let's have a festival and tell the world about our paradise."

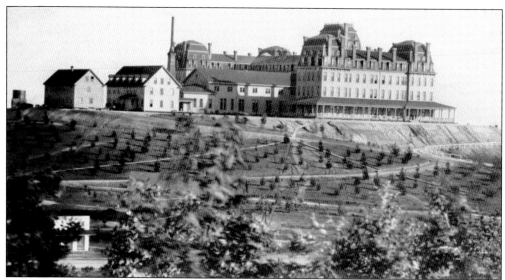

BACON HILL, NOW RAYMOND HILL, 1886. Walter Raymond chose this South Pasadena hilltop to take full advantage of the picturesque view of the mountains and surrounding vineyards, fruit orchards, and pastoral lands. This photograph was taken soon after grading and construction were complete. The deep-cut erosion visible in this image dates it to near November 1886, when a rainstorm hit the area, making muddy roads and the swollen Arroyo Seco impassable.

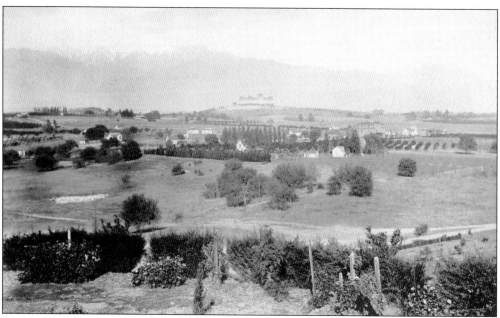

SOUTH PASADENA, 1886. The Boston-based travel agency Raymond and Whitcomb and local area boosters hyped this part of the San Gabriel Valley as a "paradise on Earth." When visitors first arrived at their winter destination, they were not disappointed. The mountains provided a scenic backdrop to almost every view of the valley.

RAYMOND HOTEL FLOOR PLAN: FIRST FLOOR. One of the most impressive features of the hotel was the veranda, which extended a good distance from the primary building's exterior walls and ran the entire circumference of the hotel.

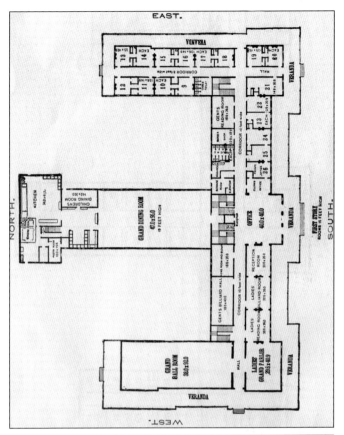

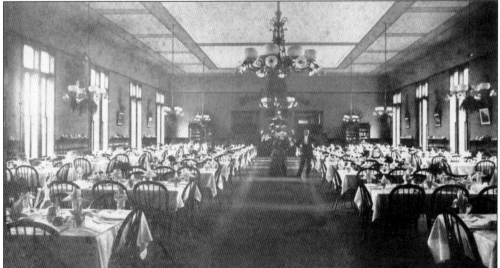

GRAND DINNING ROOM, 1893. Walter Raymond only hired experienced hotel specialists from the luxury resort hotels that were closed for the winter season in the Boston area. The opulent grand dining room extended 95 feet in length with a 19-foot-high ceiling. A separate dining room for children was located at the back of the grand dining room, behind a closed door next to the kitchen.

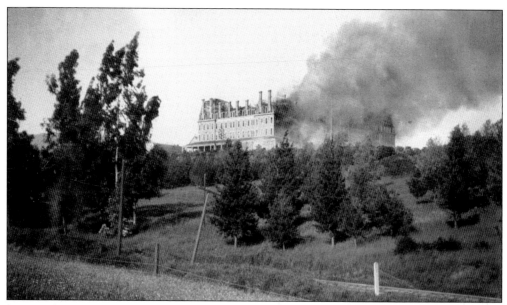

EASTER SUNDAY, 1895. The Raymond caught on fire and burned to the ground in 20 minutes. Hotel guests grabbed whatever they could and ran for safety. Property loss was staggering for the wealthier guests. They brought many comforts of home in their Pullman Palace railcars and often reserved a block of rooms. Guests of the Raymond were men of means that could easily recover their uninsured loss. (Courtesy Archives at the Pasadena Museum of History.)

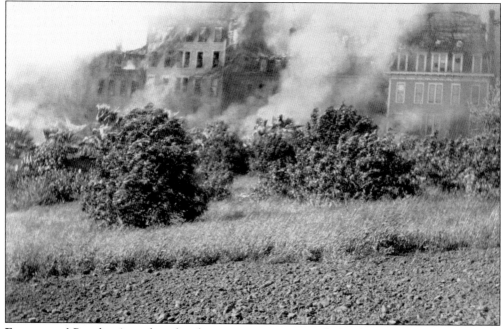

FIRESTORM! Pasadena's modern fire department was no match for the greatest single-structure fire in its history. The spark that ignited the Raymond was a glowing ember from one of the two dozen chimneys. The enormous amount of lumber used to build the hotel was now the fuel that unleashed a hellfire of flames and wind unmatched to this day. Fortunately, there was no loss of life. (Courtesy Archives at the Pasadena Museum of History.)

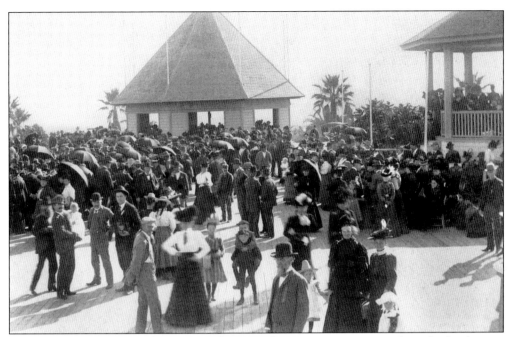

RAYMOND HILL, 1896. Walter Raymond recovered some insurance money from the fire, but not enough to rebuild the hotel. Undaunted, he built a pavilion over the site and invited the public to enjoy the famous hilltop views and share his dream of rebuilding the hotel. The hilltop had again become a community meeting place, where dancing, food, and drink were again plentiful. Walter did not easily give up his dream. (Courtesy Archives at the Pasadena Museum of History.)

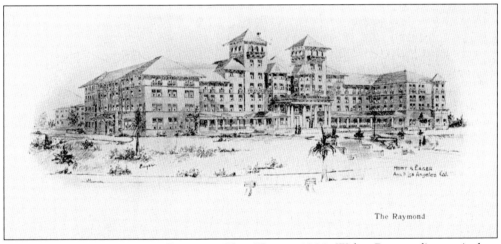

ARTIST'S RENDERING OF THE PROPOSED NEW HOTEL, 1900. Walter Raymond's son, Arthur, remembered years later: "It took my father five years to raise enough money above the proceeds of insurance to rebuild. A wealthy plumbing equipment manufacturer from Chicago, R. T. Crane [Crane Plumbing today], who had been a guest at the first Raymond, finally lent him $300,000 to make a new hotel possible."

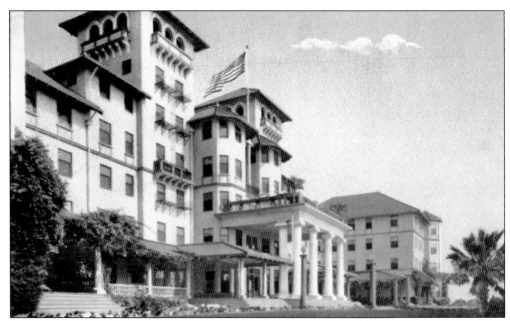

THE RAYMOND REOPENS, 1901. Arthur Raymond wrote in his unpublished autobiography (1974) about what he referred to as his father's "little speech." That speech included these lines: "When great ships are launched upon the ocean a beautiful young lady performs the ceremony, but in opening this hotel to the public I shall have it done by my little boy three years of age. Master Arthur Emmons Raymond will now launch this hotel upon what I hope will be the sea of public favor."

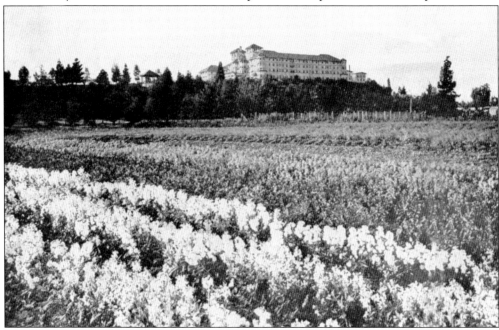

THE RAYMOND FLOWER FIELDS, 1915. A variety of flowers were grown in vast fields at the foot of Raymond Hill. Flower beds made from arroyo riverbed stone surrounded the hotel. Walkways were lined with planted flowers during the entire winter season. Cut flowers were placed everywhere inside the hotel, famously making the Raymond a floral paradise like no other hotel in the world.

GOLF AT THE RAYMOND, 1902. The orange groves around the hotel gave way to a nine-hole golf course. The pavilion used before the hotel was rebuilt had now become a golf clubhouse.

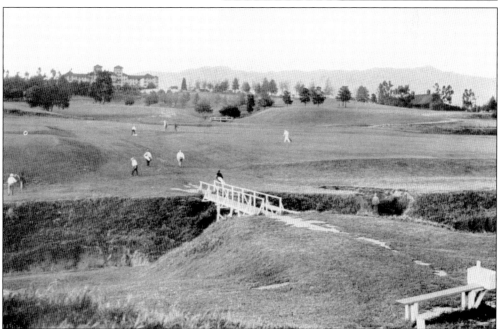

RAYMOND HOTEL PROPERTY, 1921. With the installation of the golf course, one can see just how vast Walter Raymond's hotel property was in relation to South Pasadena's emerging new business district along Fair Oaks Avenue. It included the entire hill down to the border of present-day Garfield Park.

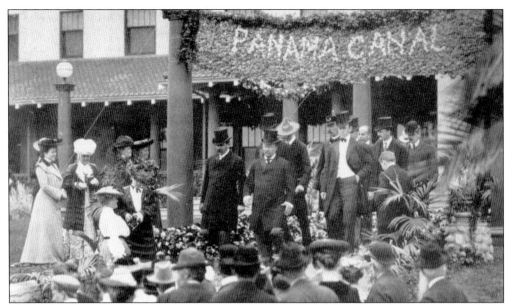

ROOSEVELT VISITS THE RAYMOND, 1903. Theodore Roosevelt was a well-traveled, energetic president. Soon after standing at the controls of a massive excavation crane in the Panama Canal, he made a grand tour of the Pacific Coast. On May 8, 1903, his first stop after arriving in California was Pasadena. On that day, he gave a speech at Wilson High School, visited Lucretia Garfield (widow of President Garfield), and had lunch at the Raymond. (Security Pacific Bank, *History of South Pasadena* community booklet, published 1923.)

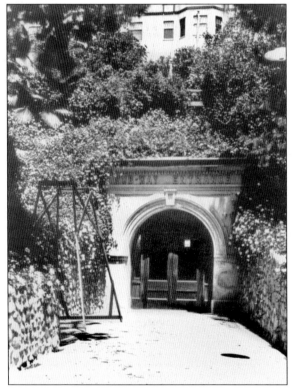

SUB-WAY HOTEL ENTRANCE, 1901. A unique feature of the second hotel was a tunnel entrance located about halfway up the hill. It was built to reduce the walking distance from the waiting station on Fair Oaks Avenue to the hilltop hotel. At the end of the "sub-way" tunnel, an elevator carried guests up to the main lobby of the hotel. Raymond boasted it was the only one of its kind in America.

VIEW OF RAYMOND HILL TODAY. Raymond Hill is completely covered with construction, including apartment buildings, a shopping center, and a freeway. The Raymond property actually extended farther down Fair Oaks (not shown) to Hope Street and Garfield Park. Raymond owned 84 acres of prime property but never incorporated. When Raymond defaulted on his bank loan, he lost everything. The site of the hotel building is at the top of this photograph.

RAYMOND STONE WALL AND PEPPER TREE. In 1934, with the hotel already closed due to sustained losses since the Depression of 1929, the bank demolished the hotel shortly after Walter's death at age 82. On the hilltop today, there is evidence of the grand hotel that once stood majestically overlooking the San Gabriel Valley. The first sign one notices is the mature palms that line the road to the flat hilltop—the site of Raymond's dream for the last 45 years of his life.

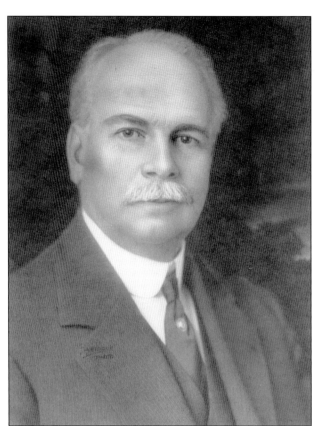

WALTER RAYMOND, 1919. Walter Raymond managed a successful travel agency, then turned into a hotel man. His two hotels on a hill in South Pasadena were vital to the prestige and early development of the region. Many wealthy visitors who later built homes in the area first came to know the Pasadena region while staying at his hotel. Walter's son, Arthur, went on to become vice-president of Douglas Aircraft Company, helping to design the DC-3 and DC-8. (Courtesy South Pasadena Library.)

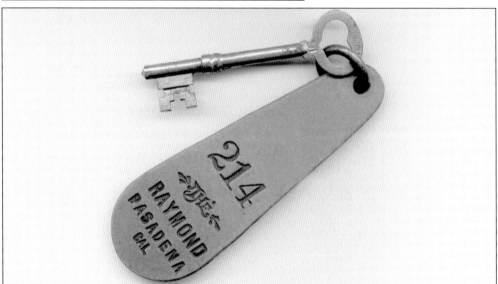

RAYMOND HOTEL ROOM KEY, C. 1903. The Raymond was the ultimate base camp for wealthy guests. They would reserve a block of rooms and remain at the hotel for the entire winter season, from a few days before Christmas to mid-April. Walter Raymond encouraged his guests to reserve the same rooms for multiple seasons. He wanted the Raymond to feel like their home away from home.

Three
CAWSTON OSTRICH FARM

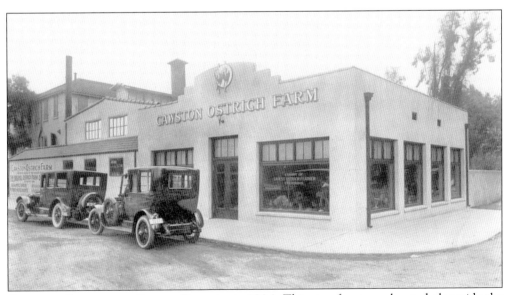

CAWSTON SHOWROOM, SOUTH PASADENA, 1924. This storefront was located alongside the factory on the South Pasadena farm grounds. Englishman Edwin Cawston initially established an ostrich-breeding farm in Norwalk in 1886 and then opened his soon-to-be-world-famous Cawston Ostrich Farm in South Pasadena in 1896. (Courtesy South Pasadena Public Library.)

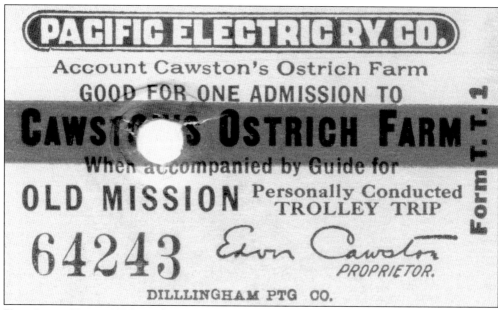

THAT'S THE TICKET! Taking the Pacific Electric trolley car was the most popular form of travel to the farm for many years. This punched ticket was issued from Cawston's store in downtown Los Angeles. It gave the holder free admission to the farm.

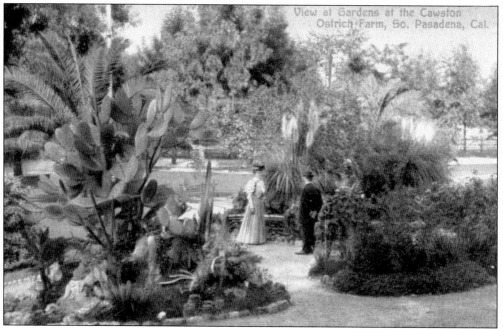

A DAY AT THE SOUTH PASADENA FARM. A young couple could spend the day at Cawston's Ostrich Farm in South Pasadena. They could take a tour of the feather dye factory, watch attendants feed whole oranges to the ostriches, and witness animal trainers ride ostriches bareback. After a midday stroll in the semitropical gardens, they could have tea at the Japanese Tea House. At the end of their visit, they could pose for a souvenir photograph with a stuffed ostrich.

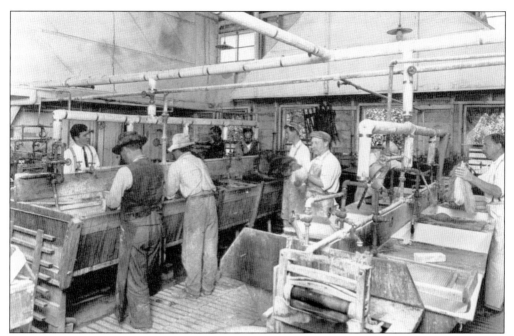

Cawston's Dye Works, 1912. Workers clean and dye feathers on the Cawston Ostrich Farm site. (Courtesy South Pasadena Public Library.)

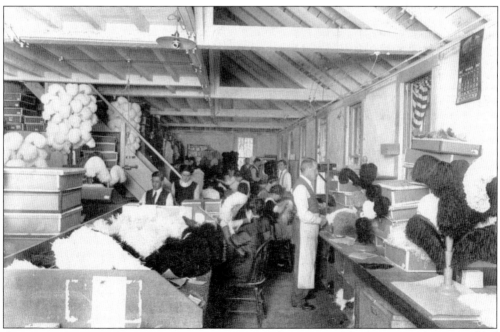

Cawston's Feather Factory, 1912. In a separate clean room of the factory, workers assembled ostrich feathers into women's clothing and prepared the garments for shipping. (Courtesy South Pasadena Public Library.)

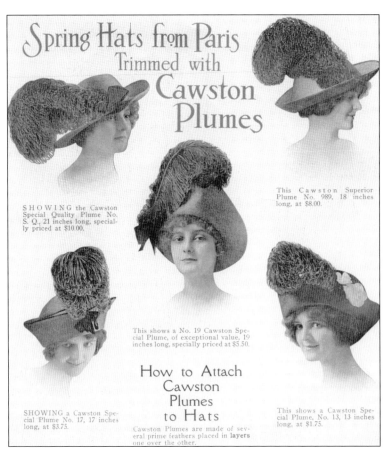

THE CAWSTON PLUME. The ostrich-feather plume was the basis of all products sold by mail order and retail direct to the public. They were attached to hats. They were woven into long flowing boas. They were sewn into simple hand-held fans. Most of all, they were considered high fashion. Cawston feathers had to be high quality in this market to cater to customers of discriminating tastes.

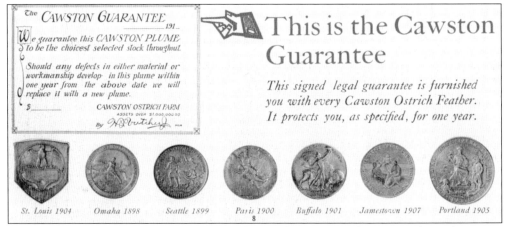

THE CAWSTON GUARANTEE. All Cawston feather products came with an unconditional one-year guarantee. To emphasize the superior quality of his plumes, Cawston often included photographs of the many medals won at World's Fairs in his brochures.

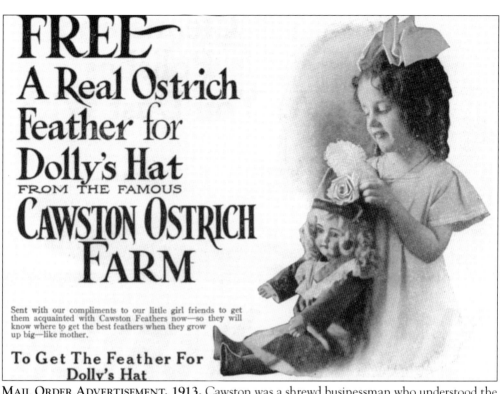

MAIL ORDER ADVERTISEMENT, 1913. Cawston was a shrewd businessman who understood the value of customer loyalty. In this advertisement, he attempted to grow his youth market.

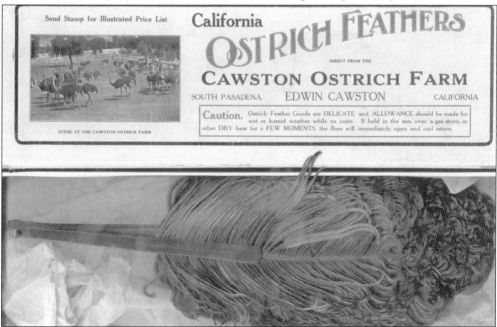

CAWSTON FAN IN A BOX. Cawston sold direct to the consumers via mail order or through company-owned and -operated stores. He never sold wholesale. The only other way to purchase a Cawston plume was on-site at his farm in South Pasadena.

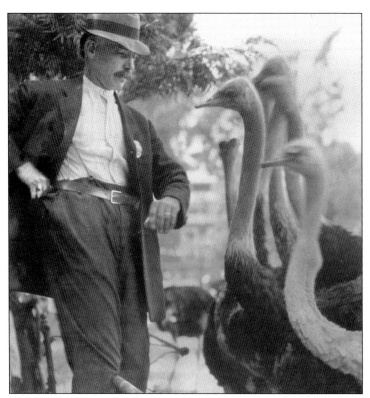

SNAKE-LIKE NECKS. Huge lumps of whole unpeeled oranges were fed to the ostriches. Ostriches were rarely seen in America before the early 20th century. Cawston's Ostrich Farm was not a typical farm-like environment or a traditional zoo setting, but akin to a modern-day amusement park that rivaled the top Southern California tourist attractions of that time.

BAREBACK OSTRICH RIDES (NEWSPAPER ADVERTISEMENT), 1926. Another entertaining feature of the farm was watching an attendant ride an ostrich bareback. Several brochures and newspapers described it as "a most difficult feat and a rare sight."

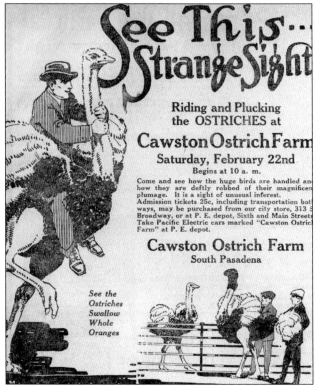

OSTRICH EGG BOOKLET, 1907. It all starts with the egg—a very large egg. This booklet told the story of the ostrich from hatching to maturity. It was produced in the actual size and shape of an ostrich egg.

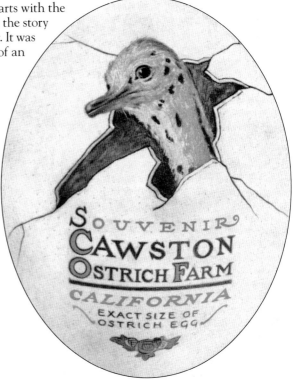

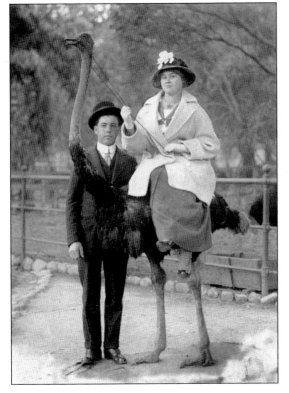

COUPLE WITH OSTRICH, 1905. Tourists loved the farm. Edwin Cawston, English adventurer and world traveler, was one of the first to realize there was big money to be made ostrich farming in America. With nearby Pasadena winter tourism at an all-time high, his goal was to attract large numbers of visitors to his farm and gain national attention in the process.

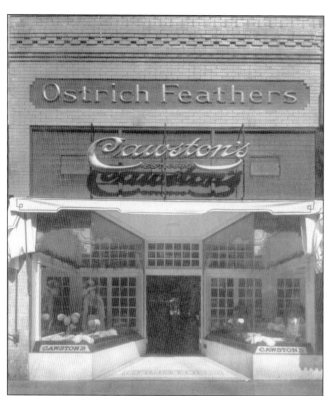

CAWSTON'S DOWNTOWN. This fancy storefront is Cawston's ostrich-feather boutique, located at 723 South Broadway in downtown Los Angeles. (Courtesy South Pasadena Public Library.)

CAWSTON'S DOWNTOWN STORE (INTERIOR). This lavish showroom in Cawston's busy business district on South Broadway shows premium plumes protected in glass cases with opulent store decorations including fresh roses and ferns. (Courtesy South Pasadena Public Library.)

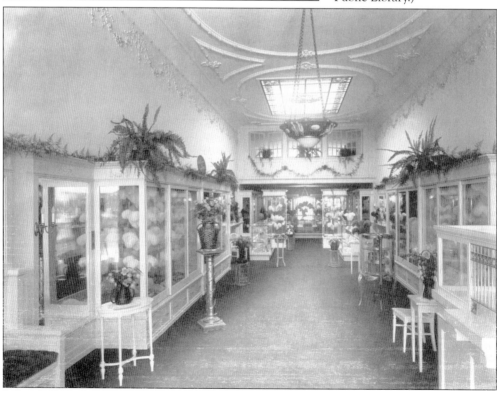

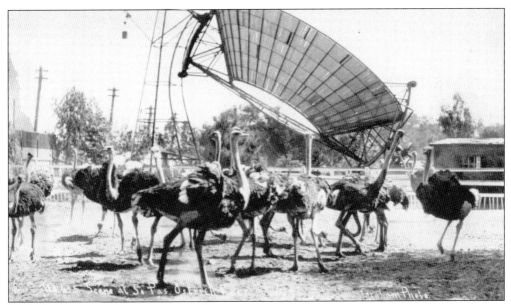

THE SOLAR MOTOR, 1901. The Cawston Ostrich farm was the site of the world's first successful experiment using a solar-powered motor for commercial use. Aubrey Eneas selected Cawston's Ostrich Farm in sunny South Pasadena to showcase his monstrous, parabolic dish. It was an odd sight: Cawston's flock of some 260 strange-looking birds milling around a six-story mechanical beast with its 1,788 mirrors flashing in the bright sun.

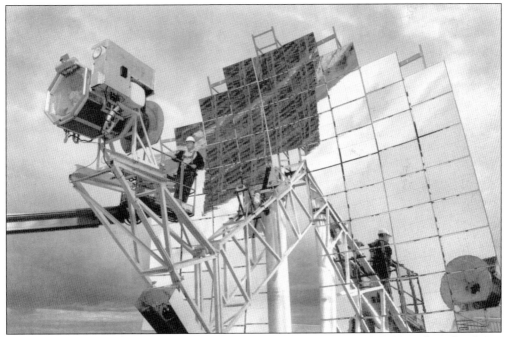

SOLAR POWER DISH TODAY. The same solar power experiments are being conducted today at Sandia's National Solar Test Facility, where concentrated solar energy is used to power a solar motor. (Courtesy Sandia National Laboratories.)

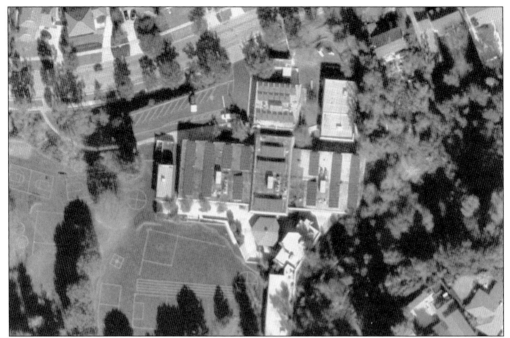

MONTEREY HILLS ELEMENTARY SCHOOL. South Pasadena's solar power heritage continues. Southern California Edison chose Monterey Hills Elementary School, ideally situated in a sunny neighborhood setting, in 1994 to install a large array of photovoltaic panels on the rooftops. Several residents in the area have also installed solar panels to take advantage of this plentiful renewable resource.

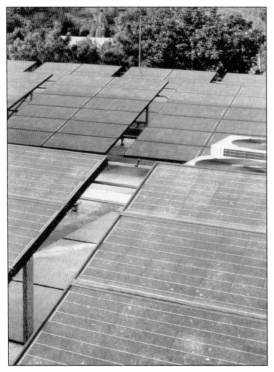

THE SOLAR SCHOOL DEDICATION, OCTOBER 19, 1994. The dedication plaque reads: "In a pioneering solar energy project, the South Pasadena Unified School District, the United States Department of Energy, the Electric Power Research Institute, and Southern California Edison have installed a solar-photovoltaic array on the roof of Monterey Hills School, The Solar School. These solar cells produce electricity without polluting air or water, reduce energy costs and help preserve precious natural resources."

Four

CITY OF TREES

"YOU WILL NOT TAKE THIS TREE!" On August 18, 1950, South Pasadena citizens made national headlines and gained support from around the country when they blockaded Edgewood Drive with cars. Armed with brooms and rolling pins, local residents gathered closely together around a 200-year-old oak tree to protect its pending removal by the city. They would not budge until the city agreed to spare the tree. (Courtesy Herald Examiner Collection, Los Angeles Public Library.)

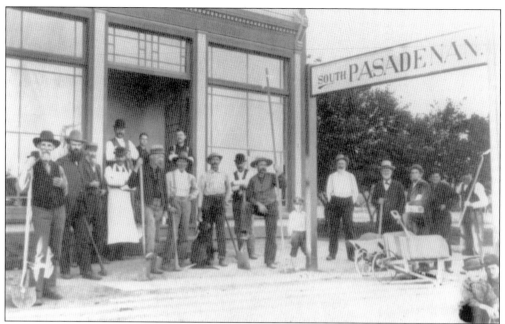

EARLY TREE PLANTING, 1894. This bunch volunteered to plant shade trees. They gathered at South Pasadena's first newspaper office, the *South Pasadenan*. Their goal was to plant 1,000 trees in the city. Many of the early city photographs show the eucalyptus trees they planted; several trees have survived to this day. One might say that South Pasadena has long been obsessed with its trees. (Courtesy South Pasadena Public Library.)

JUDGE GEORGE W. GLOVER WITH NUGGETS, 1897. Judge Glover was editor of the *South Pasadenan* and a fervent tree lover. When he died in 1929, his ashes were scattered under the trees of his home near the Arroyo Seco. (Courtesy Archives at the Pasadena Museum of History.)

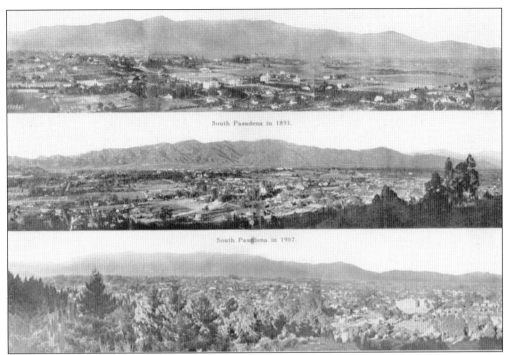

SOUTH PASADENA, 1922. Three panoramic views of South Pasadena taken from Monterey Hills show the dramatic tree growth over the span of less than 30 years. The caption on the bottom reads: "The growth of trees has been so great as to almost obscure the fact the whole valley is now filled with homes." This two-page spread appeared in the Security Pacific Bank's *History of South Pasadena* booklet, which was given away as gifts to bank members.

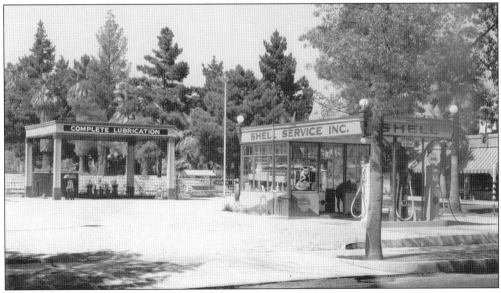

SHELL SERVICE STATION NO. 188, 1932. This Shell service station was once located on Huntington Drive at the corner of Fletcher Avenue. Notice the tree growth in the area, especially in the neighborhood behind the station. The next three streets that run parallel to Huntington Drive in South Pasadena are named Spruce, Laurel, and Oak.

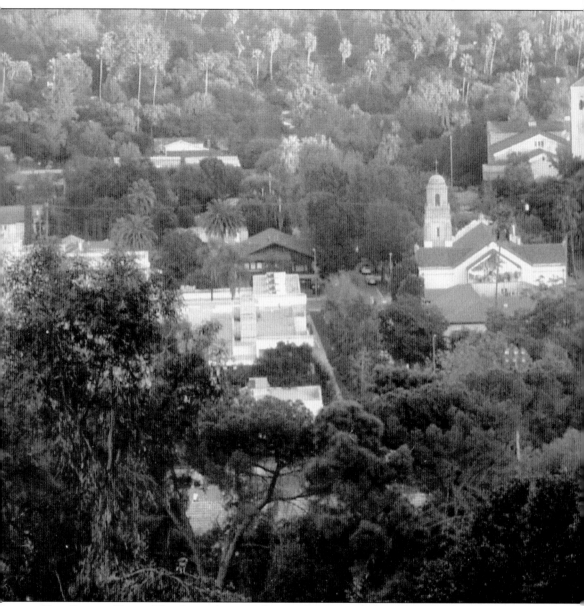

THE CITY OF TREES. The above photograph was taken recently from the city's water tank tower on Monterey Hills. There is only one structure completely visible in the foreground, a small house. A variety of trees can be seen, including palm, elm, oak, eucalyptus, magnolia, pepper, cypress, jacaranda, and pine. Try to locate the two major avenues of Freemont and Fair Oaks. Hint: find

the two large tower structures in the photograph. The Holy Family Church is on Fremont Avenue, and South Pasadena Middle School is on Fair Oaks Avenue. The neighborhood surrounding the middle school is completely invisible under the dense tree canopy.

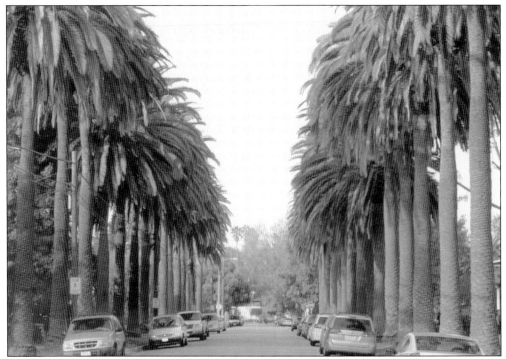

PALMS ON STRATFORD AVENUE. These magnificent mature palms are an example of a South Pasadena street with predominately the same trees. Another wonderful example of this is the jacaranda trees on Marengo Avenue. It's like purple rain when these blossoms fall, covering the road surface, cars, and people as they walk along the sidewalk. At the height of the blossoming jacaranda trees, driving down Marengo Avenue is like traveling through a purple tunnel.

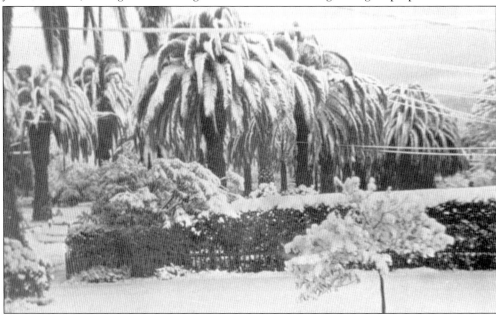

FREAK SNOWFALL IN SOUTH PAS, 1949. On January 11, 1949, South Pasadena became a winter wonderland when a freak snowfall covered the Los Angeles and San Gabriel Valley communities.

OXLEY STREET AND DIAMOND AVENUE. This spectacular tree-covered street borders the South Pasadena Public Library. When several hundred wild parrots fly overhead, it feels like being transported to a South American jungle.

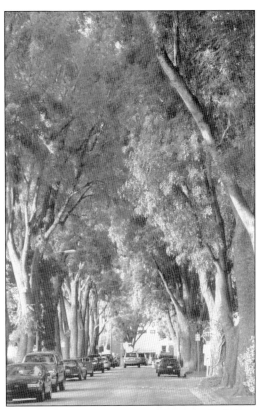

WAR MEMORIAL PARK. This California redwood tree was planted by war hero Gen. John J. Pershing on July 30, 1923.

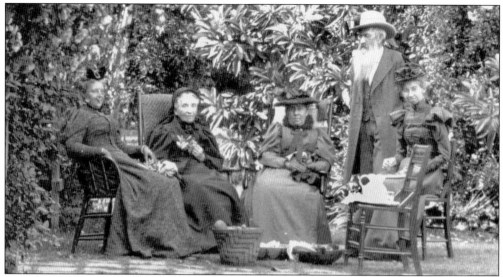

HORATIO NELSON RUST WITH GUESTS, 1895. Rust entertains women from South Pasadena's Woman's Improvement Association at his home. When he arrived in South Pasadena in 1881, he plowed up the main trail that cut across his 35-acre property and called it Monterey Road. His son, Edward H. Rust, took over the family nursery business in 1892 and began growing olive and palm trees, supplying William Wrigley Jr. with trees for his Catalina Island project.

South Pasadena is our home . . . our growing gardens have been located there since the concern was founded. We have endeavored to identify ourselves with the civic, business and social life of the community.

We take pleasure in having a part in South Pasadena's Golden Fiesta. And at this time, this institution re-affirms its confidence in South Pasadena.

It is truly "The City of Beautiful Homes."

EDWARD H. RUST
NURSERIES

EDWARD H. RUST NURSERIES (ADVERTISEMENT), 1938. During the celebration of South Pasadena's 50th anniversary (its "Golden Fiesta"), Rust took out this advertisement in the *South Pasadena Review*. The Rust Nurseries supplied orange trees for many of the groves in South Pasadena and San Marino. Today one such grove still exists surrounding the mausoleum of Henry and Arabella Huntington at the Huntington in San Marino.

Five
Tragedy Strikes Home

CRAZED SCHOOL HEAD KILLS 4 ON DEATH TOUR

Principal Goes Berserk, Shooting 6, Self In California

SOUTH PASADENA, Cal., May 6.—(AP)—Enraged because the board of education refused to renew his contract, Verlin Spencer, 38, junior high school principal, today shot and killed four school attaches and critically wounded two others and himself.

MASS MURDER MAKES NATIONAL HEADLINES, MAY 7, 1940. The news media originally reported four murders at the hands of South Pasadena's junior high school principal, Verlin Spencer. Later the number was changed to five dead and one in serious condition. Spencer survived a self-inflicted gunshot wound to his stomach and lived to see his parole from prison 30 years later.

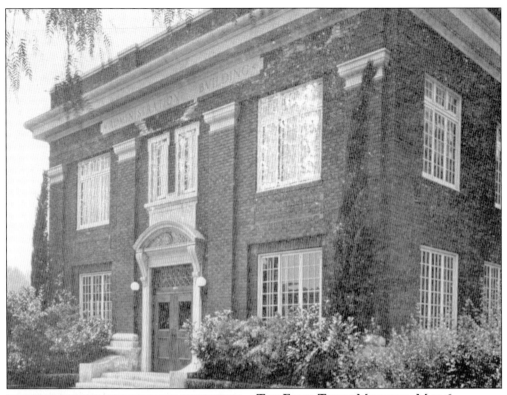

THE FIRST THREE MURDERS, MAY 6, 1940. The South Pasadena Public School Administration Building was the site of Verlin Spencer's first three murders. In a small boardroom on the second floor, Verlin was heard arguing with the superintendent of schools, George C. Bush, along with high school principal John E. Alman and Will R. Speer. The panel of school officials was assembled to hear Verlin's appeal following his dismissal as the junior high school principal. Moments later, three shots were fired and all three school officials lay dead. All were shot through the heart. (*Copa de Oro*, 1938.)

VERLIN'S MURDER RAMPAGE CONTINUED. Unsuspecting students helped Verlin jump-start his car. Then he drove to the South Pasadena Junior High School to seek revenge on others he felt had conspired against him. When he arrived, he shot and killed two more school officials, wood shop teacher Verner V. Vanderlip and teacher Ruth Barnett Spurgeon.

> May 6 - '40
>
> This is the last will and testament of I, Verlin Spencer. I am in sound mind and health as can be testified to be the Ross Loos clinic of Los Angeles
>
> I bequeath and leave all my possessions to my wife Mildred Spencer.
>
> This will, however, is to be null and void if Mildred E. Spencer, my wife, willfully pays more than 200.⁰⁰ (two hundred) dollars for my funeral expenses and medical expenses attached thereto after she has been shown this will.
>
> Verlin Spencer
>
> Witnesses

(LA3) SOUTH PASADENA, CALIF., MAY 7—SLAYER'S LAST WILL—WRITTEN A FEW HOURS BEFORE HE SHOT AND KILLED FOUR SCHOOL ATTACHES AND WOUNDED TWO OTHERS AND HIMSELF, THIS IS THE "LAST WILL AND TESTAMENT" OF VERLIN SPENCER, 38, JUNIOR HIGH SCHOOL PRINCIPAL WHO LIES NEAR DEATH IN A HOSPITAL HERE. IT STIPULATES IT WILL BE NULL AND VOID IF MORE THAN $200 IS SPENT ON HIS FUNERAL. (AP) WIREPHOTO.

ORIGINAL AP WIRE PHOTOGRAPH DATED MAY 7, 1940. Verlin Spencer wrote his last will and testament on the day he committed the murders. That document states, "I am in sound mind and health. . . . I bequeath and leave all my possessions to my wife. . . . this will, however, is to be null and void if Mildred E. Spencer, my wife, willfully pays more than $200.00 (two hundred dollars) for my funeral, expenses, and medical expenses."

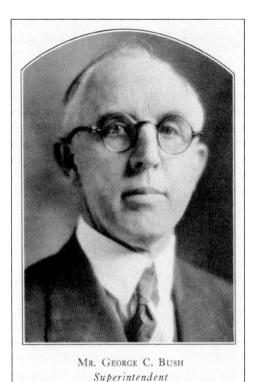

SUPERINTENDENT GEORGE BUSH. George Bush was South Pasadena's first high school principal and superintendent of schools for years at the time of his murder. (*Copa de Oro*, 1932.)

MR. GEORGE C. BUSH
Superintendent

MEMORIAL FOR THE BELOVED SUPERINTENDENT. Today the memorial built in 1940 honoring George Bush is still visited by students on campus. Many current residents have never heard of the mass murder in South Pasadena more than a half-century ago. This little-known story still holds strong memories for those in town who were old enough to recall where they were when they heard the terrible news.

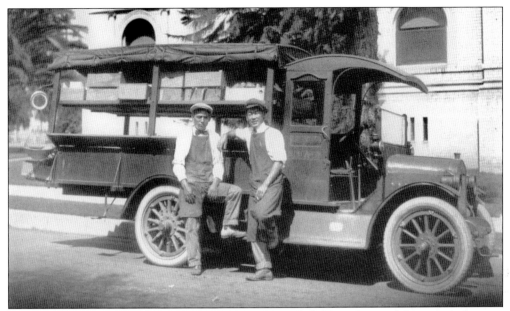

AMERICAN CITIZENS (ONE COULD STAY, ONE MUST GO). To understand the impact the next tragedy had on South Pasadena, the author has added a couple of photographs showing American citizens of Japanese descent in our community. These American citizens were loyal, hardworking, and family-oriented, with strong community ties—they were loved and respected here. (Courtesy South Pasadena Public Library.)

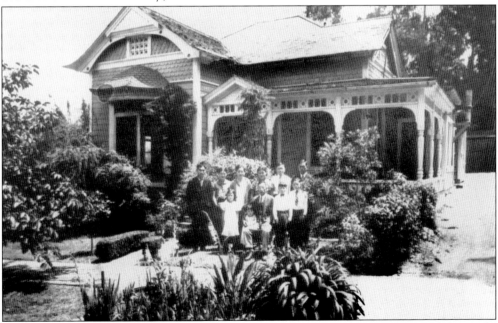

THE OTAKE AND NAMBU FAMILIES, 1935. This photograph was taken in front of the Otake home at 801 Bank Street. American citizens of Japanese descent formed a sizable portion of the population in South Pasadena in the 1920s and 1930s. The Meridian Iron Works History Museum was a Japanese American center and was used as a school before World War II. (Courtesy South Pasadena Public Library.)

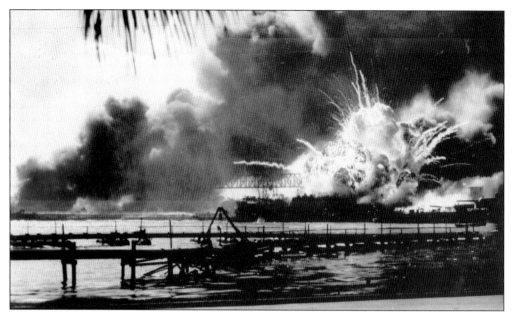

PEARL HARBOR, DECEMBER 7, 1941. Pres. Franklin D. Roosevelt called this day "a day which will live in infamy," referring to the surprise attack by the Japanese navy on the U.S. Navy's Pacific Fleet, bottled up in Pearl Harbor. On May 14, 1942, South Pasadena residents who were American citizens of Japanese descent gathered on the corner of Mission Street and Fair Oaks Avenue, where they were eventually taken to relocation camps. (Courtesy Library of Congress Archive.)

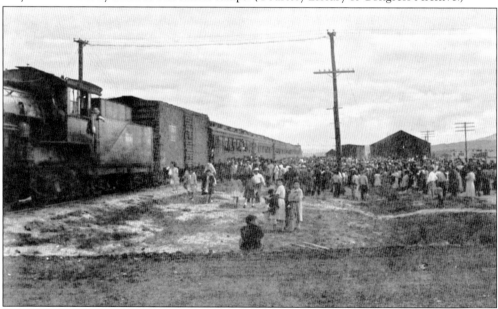

MR. SATO REMEMBERS. South Pasadena resident William Sato remembered the train ride to the relocation camp: "I thought, what's going to happen to us? And as we went over Cajon Pass into the desert I said 'Oh, Jesus Christ, they're going to put us in the desert and they're going to line us up and kill every Goddamn one of us.' I really thought that." William Sato's interview, "Stories from Home South Pasadena," is available at the Meridian Iron Works Museum and South Pasadena Public Library. (Courtesy Mori Shimada, Japanese American National Museum.)

RAY AND HIS HOG, 1938. Motorcycle officer Ray Rogers was killed during a high-speed pursuit on the Arroyo Seco Parkway on April 15, 1944. Rogers was the only police officer killed in the line of duty in the history of the South Pasadena Police Department. (Courtesy South Pasadena Police Department.)

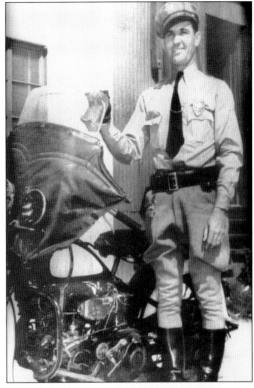

MEMORIAL FOR OFFICER RAY E. ROGERS. This memorial plaque is displayed on the inner courtyard wall at South Pasadena City Hall, near the entrance to the police department. The brief six-year period in the 1940s that saw so much tragedy for our small community was about to end.

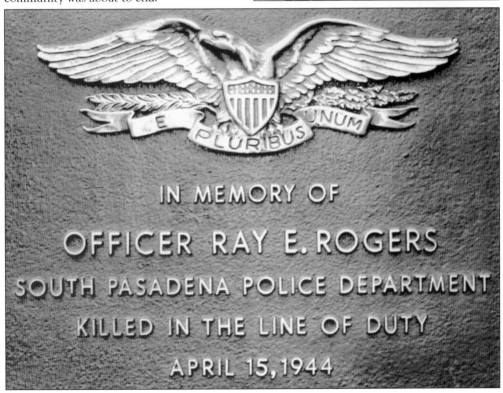

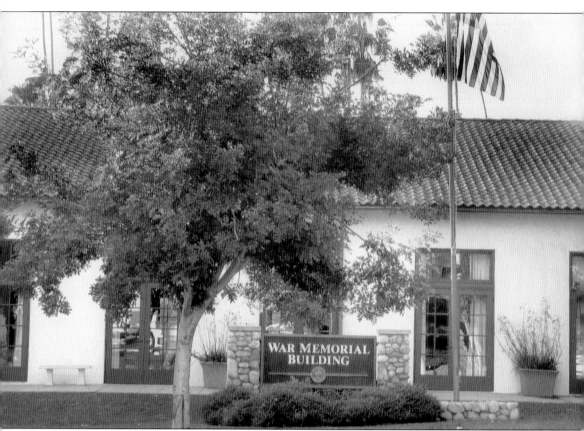

WAR MEMORIAL BUILDING. The South Pasadena War Memorial Building was designed by architect Norman Marsh and built in 1921. On August 14, 1945, after two cities in Japan—Nagasaki and Hiroshima—were devastated by nuclear bombs, the Empire of Japan finally agreed to an unconditional surrender. The war in the Pacific was over. Germany was defeated. Forty-nine South Pasadena residents who fought in the war never returned home.

Six

THE FIGHT

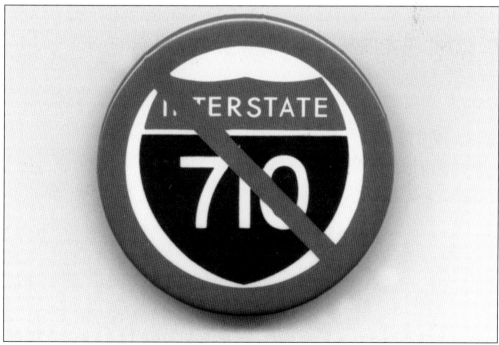

A SYMBOL OF THE FIGHT. Famed industrial designer Henry Dreyfuss offered his South Pasadena studio as a meeting place during the early stages of the freeway fight. Dreyfuss said it would be "suicide" if the group acquiesced to the California Department of Transportation's plans to build the 710 Freeway through the city. Today the fight has become a national debate. Freeways may in fact be undesirable if they threaten a city's right to exist.

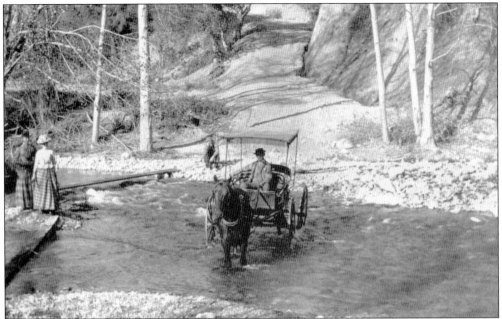

CROSSING THE ARROYO SECO, 1900. One man crosses the Arroyo Seco in his horse and buggy while another man watches safely on the river's edge. Two women make their way across the river by foot over long wooden boards. Early crossings were especially treacherous when the arroyo was swollen during rainfall. Dirt roads were often maintained at the whim of local property owners. (Courtesy Archives at Pasadena Museum of History.)

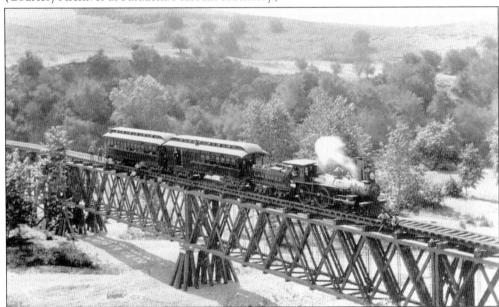

LOS ANGLES AND SAN GABRIEL VALLEY RAILROAD COMPANY (LA&SGVRR), 1885. The first major railroad from Los Angeles to Pasadena went through the heart of present-day South Pasadena. This railroad venture was sold to the Santa Fe Railroad, which operated the region's first intercontinental route across America. The same route runs through South Pasadena today as the Metro Gold Line. (Courtesy Archives at Pasadena Museum of History.)

RAILROAD TRESTLES ENTER SOUTH PASADENA. As Pasadena and the greater San Gabriel Valley population and business interests grew, so did transportation ventures. Competing railroads laid track parallel as they entered South Pasadena. These trestles were built over the Arroyo Seco in the exact same place as the earlier land crossing. The York Street Bridge was built at this location when automobiles arrived on the scene. (Courtesy Archives at Pasadena Museum of History.)

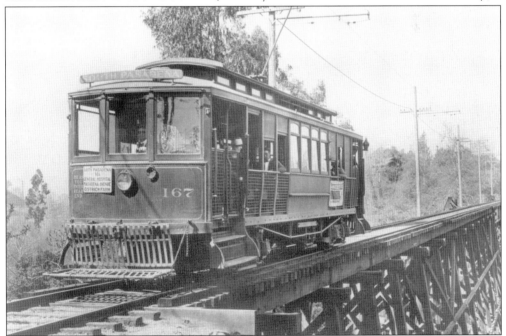

SOUTH PASADENA RED CAR. The South Pasadena electric car traveled from downtown Los Angeles, eventually crossing the Arroyo Seco at South Pasadena to reach its destination on Pasadena Avenue at the Cawston Ostrich Farm. By the 1920s, South Pasadena had five separate rail-track routes crossing the city: electric car tracks on Mission Street and the full length of Fair Oaks Avenue as well as those of the Southern Pacific, Sante Fe, and Salt Lake Railroads. (Courtesy Archives at Pasadena Museum of History.)

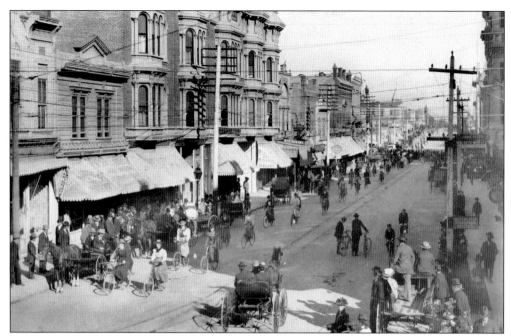

COLORADO STREET, PASADENA, 1898. Hundreds of bicyclists parade down Colorado Street in a show of force to impress city planners for road improvements and more places to ride. (Courtesy Archives at Pasadena Museum of History.)

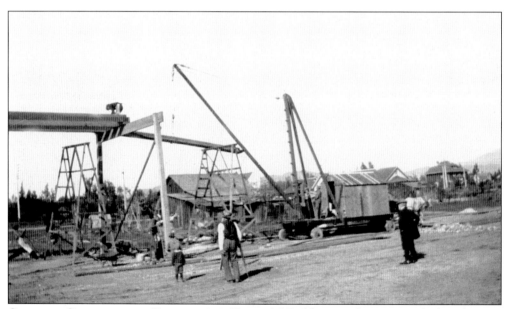

CYCLEWAY CONSTRUCTION BEGINS, 1899. Horace M. Dobbins was listening to the bicycle-crazy public. He began construction of an elevated cycleway, which left from the Green Hotel and ran parallel between Fair Oaks and Raymond Avenues toward Raymond Hill in South Pasadena. (Courtesy Archives at Pasadena Museum of History.)

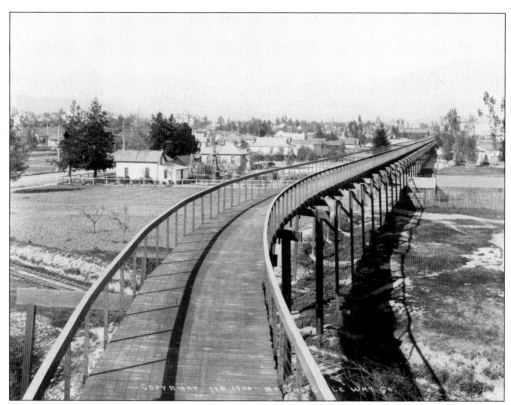

DOBBINS ELEVATED CYCLEWAY, 1900. When Dobbins started the California Cycleway Company in 1897, his goal was to build the region's first road from Pasadena to Los Angeles, using the Arroyo Seco as the primary route. (Courtesy Dobbins Collection, Archives at Pasadena Museum of History.)

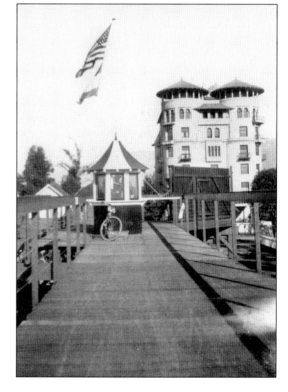

CYCLEWAY TOLL BOOTH AT THE GREEN HOTEL, 1900. The first phase of the cycleway was opened on New Year's Day, 1900, and ran between the Green and Raymond Hotels. The second phase of intended construction to Los Angeles was never built. (Courtesy Dobbins Collection, Archives at Pasadena Museum of History.)

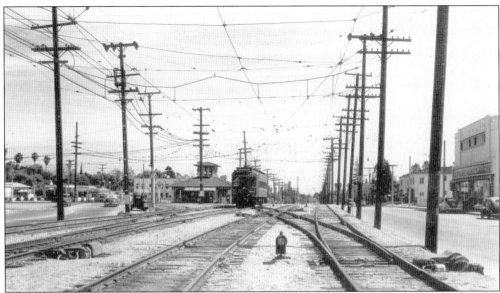

HUNTINGTON DRIVE LOOKING TOWARD ONEONTA STATION (FAIR OAKS AVENUE). It was acknowledged at the time by transportation experts that South Pasadena had the best commuter rail system of any city its size in the world. Public transportation via the Pacific Electric car and private automobiles, growing in popularity, often shared the same primary routes. (Courtesy South Pasadena Public Library.)

CAR DEALERSHIP ON FAIR OAKS AVENUE NEXT TO THE RIALTO. The Route 66 Historic Route (1926–1931) came down Fair Oaks Avenue to Huntington Drive in South Pasadena and then on to Seventh Avenue and Broadway in downtown Los Angeles. Fair Oaks Avenue and Mission Street were once lined with automobile dealerships, gasoline stations, garages, and repair facilities. The Southern California motoring public was car-crazy, and South Pasadena catered to the Route 66 traveler like no other city. (Courtesy South Pasadena Public Library.)

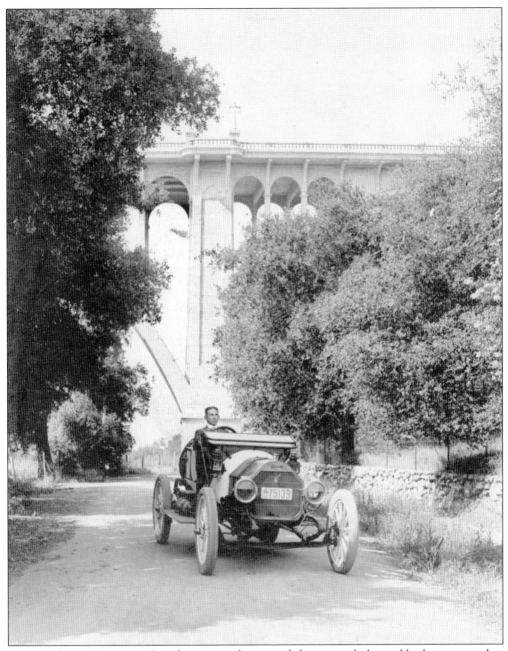

ARROYO SECO MOTORIST. Pasadena privately rejected the original planned highway route that was to run the entire length of the Arroyo Seco through Pasadena's Busch Gardens, passing under the Colorado Bridge and alongside Brookside Park and the Rose Bowl toward Devil's Gate (at the 210 Freeway today). Pasadena officials met with Los Angeles County transportation officials to encourage South Pasadena to accept the many benefits of building a major highway through their smaller city. (Courtesy Archives at Pasadena Museum of History.)

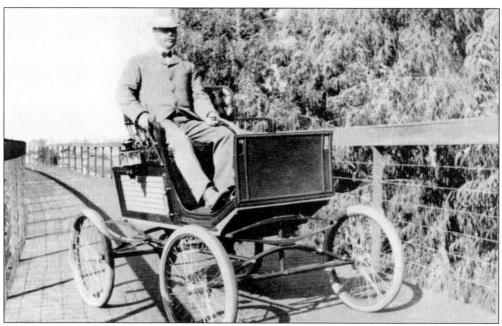

GRANDFATHER OF THE PASADENA FREEWAY, 1900. Horace Dobbins sits in his first automobile. Dobbins is referred to as the Grandfather of the Pasadena Freeway because his California Cycleway Company proposed the region's first road from Pasadena to Los Angeles. That proposed route intended to use the Arroyo Seco landscape. Almost immediately after he built the cycleway, automobiles began to dominate travel on surface roads. The cycleway was dismantled for its lumber. (Courtesy Dobbins Collection, Archives at Pasadena Museum of History.)

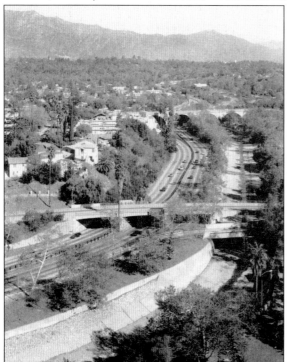

ARROYO SECO PARKWAY. Los Angeles officials approached South Pasadena with plans to build an East Coast–style parkway thoroughfare. South Pasadena's elected officials allowed the city's Arroyo Park to be divided by the four-lane highway. Apartment complexes sprang up in South Pasadena at the Orange Grove and Fair Oaks Avenues exits. Center rails were installed, and the original park-like landscaping was neglected over time. (Courtesy Library of Congress Archives.)

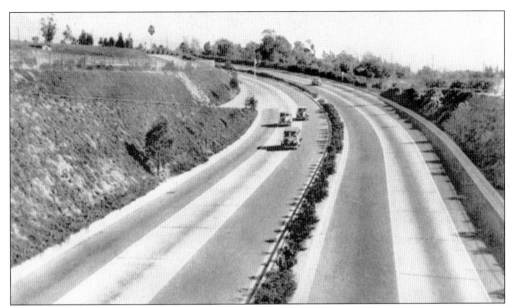

THE RAYMOND HILL CURVE. Soon after its completion, the Arroyo Seco Parkway was dubbed the "Arroyo Speedway" because of speeding vehicles. The highway was not engineered for the increasingly powerful engines that could produce higher-speed vehicles. The Fair Oaks Avenue off-ramp at South Pasadena, seen on the left, was closed due to the danger of collisions from vehicles traveling at high speeds on the Raymond Hill curve. (Courtesy Pomona Public Library.)

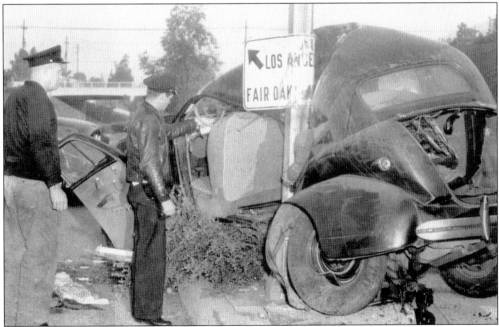

FATALITY AT FAIR OAKS AVENUE. This vehicle exiting the "Arroyo Speedway" met with a tragic end. The Arroyo Seco Parkway received an official name change to Pasadena Freeway, which upset many South Pasadena residents, who felt duped into accepting the freeway under false pretenses. Opponents of the current 710 Freeway extension are quick to point out that at no point does the Pasadena Freeway ever exist in Pasadena. (Courtesy South Pasadena Police Department.)

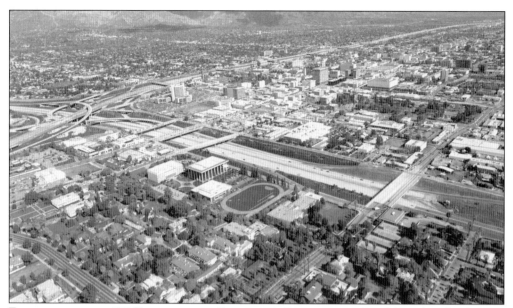

EXTENSION OF THE 710 FREEWAY FROM PASADENA'S PERSPECTIVE. South Pasadena has been at the crossroads for centuries. That distinction—a curse to the residents who live here—continues to this day. For more than 40 years, South Pasadena residents have fought against building the 710 Long Beach Freeway through the heart of their city. Caltrans calls the proposed freeway extension a "gap closure." (Courtesy Archives at Pasadena Museum of History.)

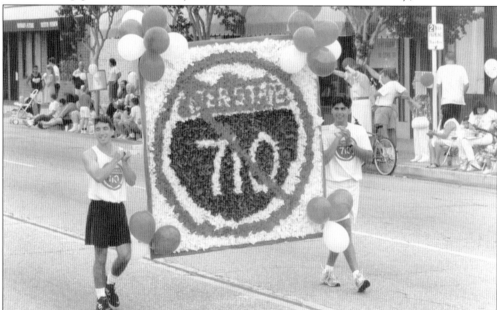

FREEWAY FIGHTERS. Two youthful fighters carry the anti-710 symbol along the Fourth of July Parade route on Mission Street. South Pasadena has a colorful history of those willing to do battle: Thelma Clark, Ted Shaw, Bob and Bea Siev, Elizabeth Madley, Clarice and Harry Knapp, Amedee "Dick" Richards, Jess Reynolds, Joanne Nuckols, Sam Knowles, Anita and Diana Stoney, Dave Margrave, Jane Matyas, Bill and Mary Lee Harker, Mary Ann Parada, and Alvalee Arnold. (Courtesy Henk Friezer Photography.)

GEORGE AND MIKE, 1971. "To my friend Mike from another freeway fighter. Senator George Mascone." Legendary freeway fighter Sen. George Mascone later became mayor of San Francisco and was assassinated while in office, a circumstance that launched the political career of Sen. Dianne Feinstein. Council member Mike Montgomery later became mayor of South Pasadena and continued to fight the freeway.

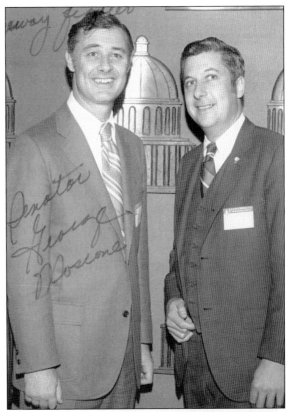

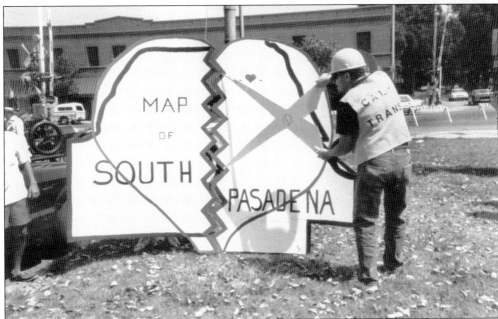

"JUST CUT ALONG THE DOTTED LINE," 1993. The "dotted line" in this case refers to the proposed Meridian Route for the 710 Freeway through the heart of the city, a cut that registered to residents as both geographical and figurative. (Courtesy Henk Friezer Photography.)

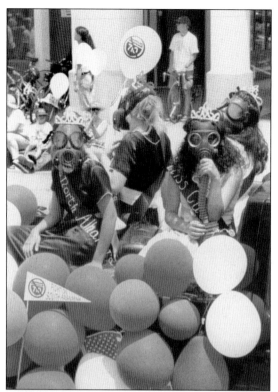

Miss Caltrans. During a Fourth of July parade, young participants mock local communities and Caltrans for their support of the 710 Freeway. These "beauty queens" wear gas masks to dramatize the reality that communities near major freeways suffer from greater concentrations of noise and air pollution. (Courtesy Henk Friezer Photography.)

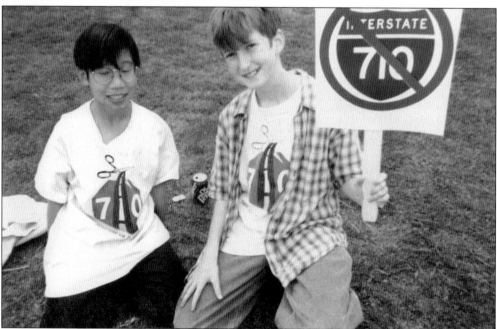

Two Young Freeway Fighters. Another fighter was a South Pasadena High School student named Jannie Kwok, who led a successful rally called "Youth Against the 710 Freeway" to create awareness by walking the proposed 710 Freeway route in South Pasadena with her fellow students. (Courtesy Henk Friezer Photography.)

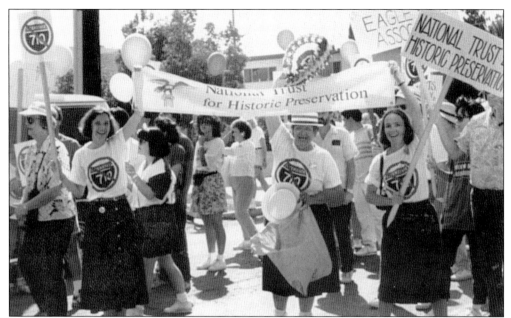

"ONE OF AMERICA'S MOST ENDANGERED PLACES." South Pasadena was named by the National Trust for Historic Places to its top-10 list of most endangered landmarks for five straight years. It has been the only city named by the trust. In the above photograph, longtime fighter Mary Ann Parada (center) has been instrumental over the years in helping to maintain community awareness with Citizens United to Save South Pasadena.

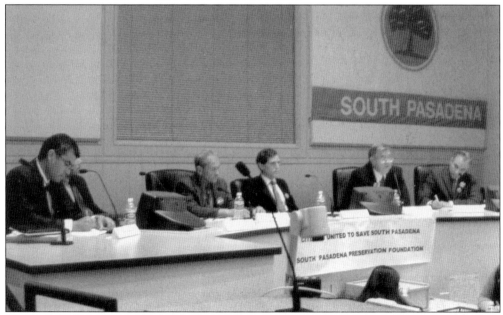

CANDIDATE FORUM, 2007. City hall was the stage for a candidate forum held on January 30, 2007, cosponsored by the South Pasadena Preservation Foundation and Citizens United to Save South Pasadena. Candidates running for city council answered questions focused on their positions related to the 710 Freeway/Tunnel and preservation issues as they impact the quality of life in South Pasadena. A flash point of discussion centered on the tunnel option.

Route 710 Tunnel Technical Feasibility Assessment Report

Task Order PS-4310-1268-05-01-2

Submitted to:

Los Angeles County Metropolitan Transportation Authority
One Gateway Plaza
Los Angeles, CA 90026
MS 99-22-8

Submitted by:

June 7, 2006

THE TUNNEL. Constructing a tunnel under South Pasadena has been discussed for years. Many dismissed the idea, thinking it was too costly or technologically impossible. With no other place to go in the 40-year 710 fight, a feasibility study was finally conducted to resolve the matter. Many were hopeful that this would be the ultimate solution, until a *Los Angeles Times* article raised questions about health issues surrounding two proposed 100-foot towers.

TUNNEL BORING MACHINE (TBM). This massive drill was used for a tunnel project that was conducted in Madrid, Spain. The TBM used for tunneling under South Pasadena would be 10 feet wider.

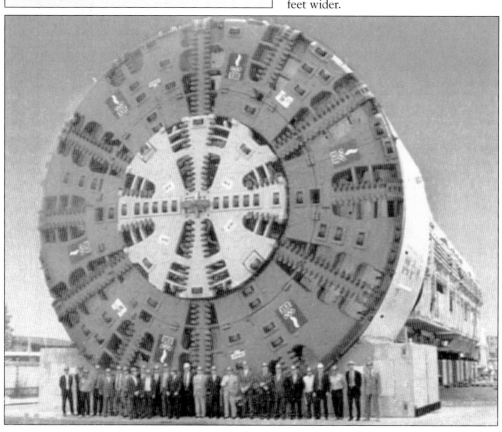

Seven

THE POWER OF DREAMS

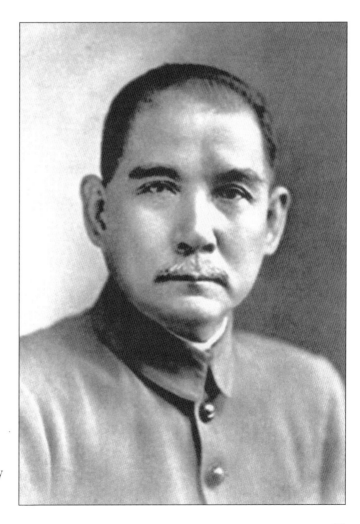

DR. SUN YAT-SEN. Known today as the Father of Modern China, Sun Yat-Sen is revered in both the mainland of China and Taiwan. Sun's enduring legacy is the Three Principles of the People—nationalism, democracy, and the people's livelihood/welfare. (Courtesy Library of Congress National Archives.)

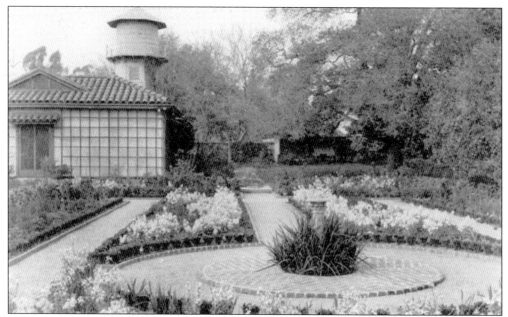

CHARLES BEACH BOOTHE RESIDENCE. Boothe, code-named "Red Dragon," was in effect the treasurer of a revolution. In 1910, he received official documents making him a secret agent to assist Sun Yat-Sen in his efforts to overthrow the Qing Dynasty. In return for their financial backing and political support, Boothe's fellow American backers hoped to gain access to China's many natural resources. Sun reportedly spent several weeks at the South Pasadena Boothe residence in 1910. (Courtesy California State Library.)

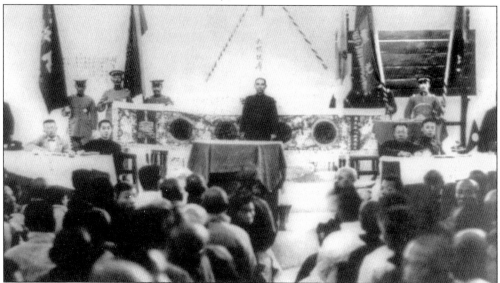

PRES. SUN YAT-SEN. Sun played an important role in the overthrow of the Qing Dynasty in 1911 and was briefly named the first president of the Republic of China. He continued to struggle against the warlords that controlled much of China. In the above photograph, Sun, president of the Cantonese government, addresses an audience in his home of Kweilin (Kwangsi province) just before departing with troops on his campaign against Peking. (Courtesy Library of Congress National Archives.)

ROY KNABENSHUE, 1913. This rare photograph shows Knabenshue as the dashing aeronaut. Walter Raymond's son, Arthur, credits Roy for his lifelong passion for flight, which later led him to design such classic aircraft as the DC-3 and DC-8. (Courtesy R. W. Flan's Roy Knabenshue Album Collection.)

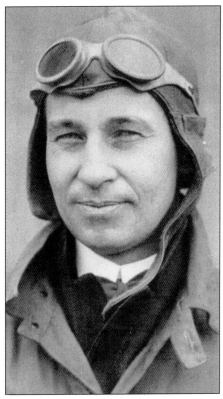

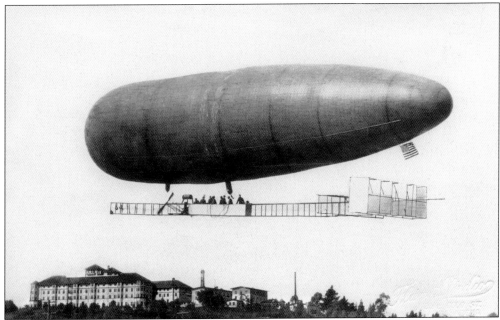

FIRST PASSENGER AIR SERVICE IN AMERICA. Knabenshue took paying customers up on an 800-foot-high flight over the San Gabriel Valley in his dirigible. His large wooden hanger was located near the Raymond Hotel in South Pasadena. (Courtesy Archives at the Pasadena Museum of History.)

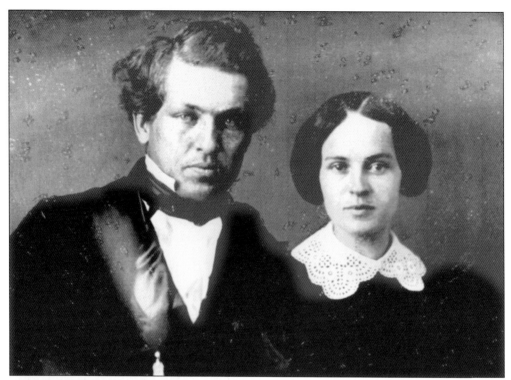

CRETE AND JAMES. During their courtship, Lucretia "Crete" Rudolph wrote James Garfield while separated on New Year's evening, 1856: "Where ever you may be I know you are with me in spirit, and upon my lips I *almost* feel the fond kiss your ardent love places there." To this James replied, "your dear little message of love passed over the wide wintry waste that lies between us, to reach me. . . . your letters are like dear little drops of yourself, sweet roses from the full garden of your heart." (Courtesy Western Reserve Historical Society Library.)

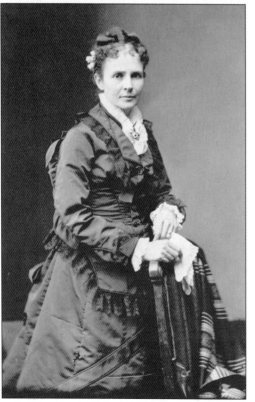

LADY IN BLACK. After President Garfield was assassinated by a disgruntled office seeker, Lucretia Garfield was forever referred to as the widow of martyred Pres. James A. Garfield. She adhered to her own strict interpretation of Victorian values, always wearing black in public. Mrs. Garfield remained active while in South Pasadena and became cofounder of the Pasadena Red Cross at the beginning of World War I. (Courtesy Library of Congress National Archives.)

THE GARFIELD RESIDENCE, 1910. Horn's Military Band poses for a photograph in front of Mrs. Garfield's home during South Pasadena's Flag Day celebration. Mrs. Garfield chose Buena Vista Street in South Pasadena to build her winter home. In 1904, the famous architects Charles and Henry Green designed and built this Craftsman bungalow, with Mrs. Garfield's active involvement in the project. (Courtesy South Pasadena Public Library.)

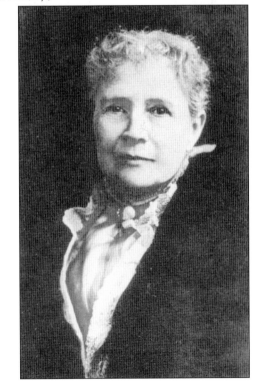

"MRS. GARFIELD ANSWERS CALL." The beloved first lady was so revered in her time that Pres. Theodore Roosevelt only accepted an invitation to visit Pasadena if he could schedule a visit to see the former first lady. In public, Mrs. Garfield always wore a medallion around her neck in remembrance. She died of pneumonia at the age of 86 at her home in South Pasadena. One national newspaper headline read: "Mrs. Garfield Answers Call."

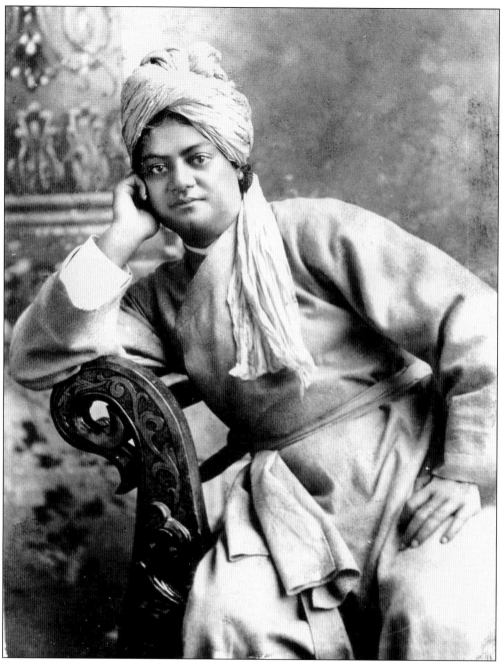

SWAMI VIVEKANANDA. Vivekananda's inspiring personality was well-known both in India and America at the beginning of the 20th century. He made an immediate impression on the American public when he represented Hinduism at the Parliament of Religions at the Chicago World's Fair of 1893. In America, Vivekananda's mission was the interpretation of India's spiritual culture. Vivekananda once said: "Religion is not in books, nor in theories, nor in dogmas, nor in talking, not even in reasoning. It is being and becoming." Vivekananda was the first swami of many that came to America in the early 1900s. (Courtesy Vedanta Society of Southern California, Hollywood.)

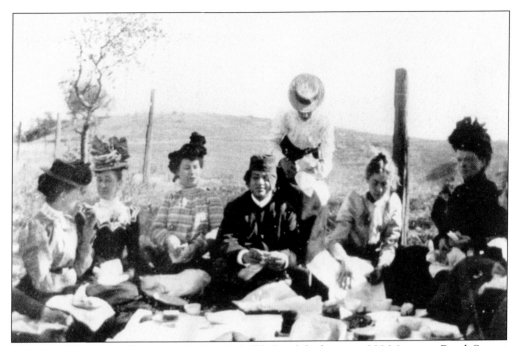

PICNIC IN MONTEREY HILLS, 1900. On the hill behind the house at 309 Monterey Road, Swami Vivekananda is a guest of the homeowner and what is most probably South Pasadena's newly formed women's club, which was very enlightened on many of the spiritual and social issues of the day. (Courtesy Vedanta Society of Southern California, Hollywood.)

SWAMI VIVEKANANDA VISITS SOUTH PASADENA, 1900. In 1900, Swami Vivekananda stayed at this house on Monterey Road for six weeks. The home is a shrine today, and the bedroom where Vivekananda slept is now a sanctuary for meditation. (Courtesy Vedanta Society of Southern California, Hollywood.)

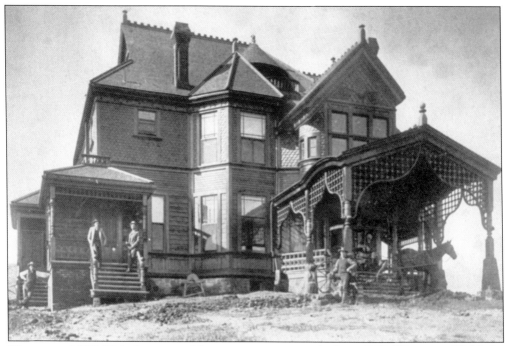

WYNYATE, 1887. This three-story Victorian mansion was built in 1887. *Wynyate* is Welsh for "vineyard." The home, located at 851 Lyndon Street, is a South Pasadena Cultural Heritage Landmark and on the National Registry of Historic Places. (Courtesy South Pasadena Public Library.)

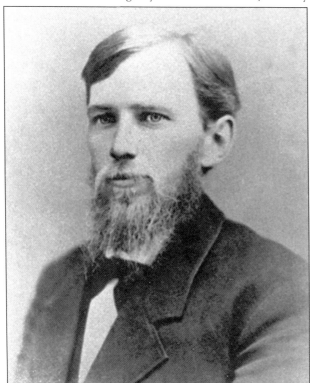

DONALD M. GRAHAM. South Pasadena's first mayor, Graham built Wynyate mansion on an upslope that forms Monterey Hills today. In the above photograph, he is the man standing second from the left on the stairs. The house was designed by architect W. R. Norton. (Courtesy South Pasadena Public Library.)

MARGARET COLLIER GRAHAM. Graham was a well-known writer and literary figure in her time. She was highly respected for her series of stories about the West. The Grahams would often host community events at their home, which Margaret Graham continued after the early death of her husband. (Courtesy Archives at the Pasadena Museum of History.)

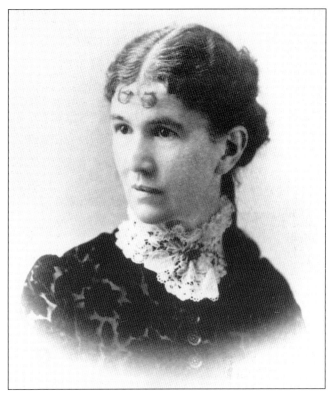

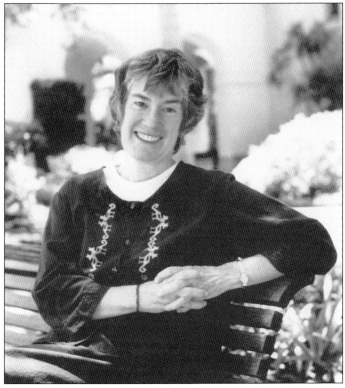

AN EVENING WITH MARGARET COLLIER GRAHAM. Accomplished local history writer Elizabeth Pomeroy portrays South Pasadena storyteller Margaret Collier Graham, reading from Graham's book of republished works. Pomeroy remains in character even during the book signing.

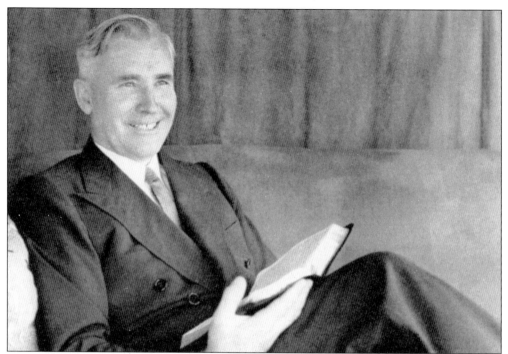

CHARLES E. FULLER, 1940. Charles Fuller had a home in South Pasadena described in the best-selling book *The Old Fashioned Revival Hour and the Broadcasters*, by J. Elwin Wright, as "an attractive English, washed-brick home located adjacent to the towering, wide-branched trees providing a lovely green canopy for the street."

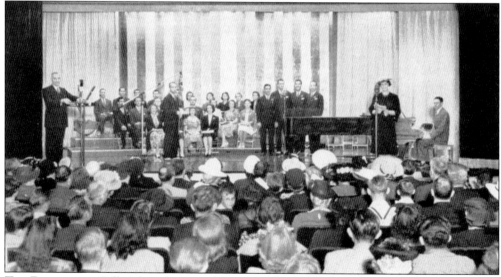

THE BROADCAST. Fuller's broadcast was known as *The Old Fashioned Revival Hour* in the 1930s and 1940s. Every Sunday night, several million people sat by their radios to hear Reverend Fuller's ministry. Reverend Fuller (left) and "Rudy" Atwood and his Quartette (right) specialized in broadcasts that seemed to reach right into people's living rooms and make a personal connection. At the height of his popularity, South Pasadena's Fuller filled huge auditoriums and broadcast the service live.

WILLIAM HOLDEN, 1954. William Holden, who was born William Franklin Beedle Jr. in Illinois and grew up in the Pasadena area, was just one famous actor who attended South Pasadena High's "School of Dreams." This *Life* magazine cover features Holden as the top movie star of 1954.

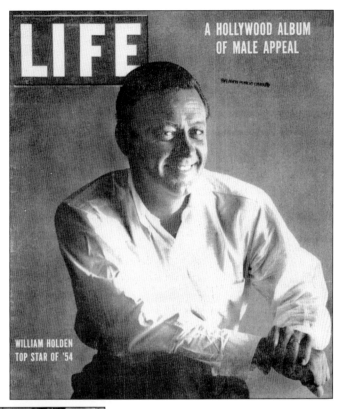

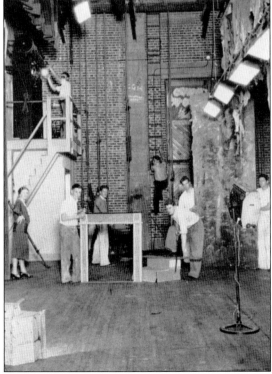

SOUTH PASADENA HIGH SCHOOL BACKSTAGE, 1930. Two Academy Award–winning actors have attended South Pasadena High School: William Holden, who won for *Stalag 17* (1953), and two-time winner Hilary Swank, whose statuettes were for *Boys Don't Cry* (1999) and *Million Dollar Baby* (2003). Other notable actors include Jaleel White (class of 1994), popular star of the hit television show *Family Matters*, in which he played Steve Urkel, and Bronson Pinchot (class of 1977), star of the hit show *Perfect Strangers*. (*Copa de Oro*, 1930.)

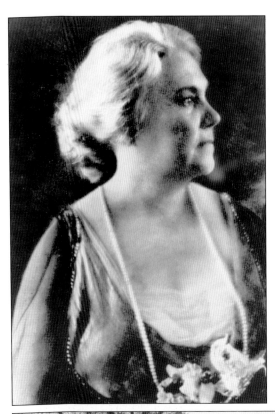

MINERVA HAMILTON HOYT, 1938. Hoyt was a South Pasadena socialite whose infant son died, and she felt compounded loss soon after when her husband, Dr. Sherman Hoyt, died in 1918. She found new courage and dedicated her life to protecting the deserts. (Courtesy Archives at the Pasadena Museum of History.)

JOSHUA TREE NATIONAL PARK. Minerva Hamilton Hoyt was instrumental in convincing Pres. Franklin D. Roosevelt to declare the California desert land called Joshua Tree a national monument in 1936. Because of her relentless crusade to preserve the deserts of Southern California, she is affectionately called "Apostle of the Cacti."

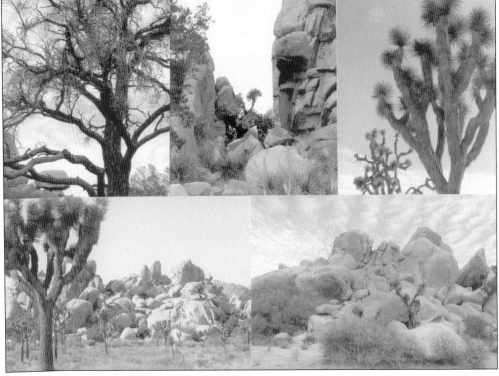

A. S. C. Forbes. Another influential South Pasadena woman who tried to protect California heritage was A. S. C. Forbes, but Forbes was more interested in preserving human cultural heritage. Her crusade was for bringing attention to the trail that connected California's old mission system, El Camino Real. (Courtesy Los Angeles Public Library.)

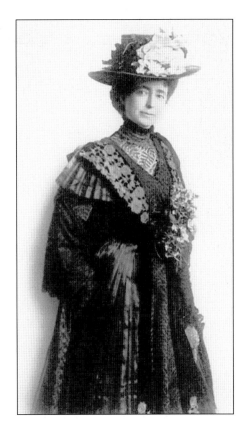

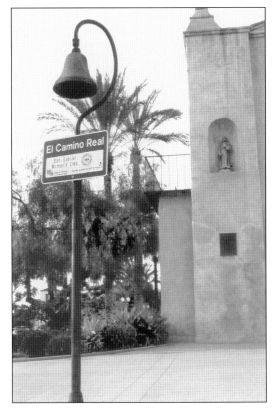

The Bells of El Camino Real. A. S. C. Forbes was tireless in her mission to cast literally thousands of bells to be placed along the historic roads between the California missions.

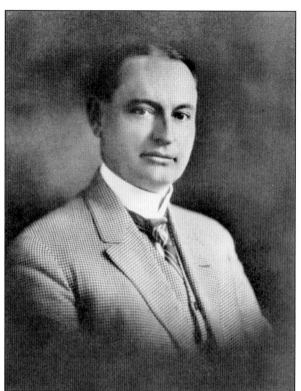

NORMAN FOOTE MARSH. Architect Norman Foote Marsh was responsible for designing nearly every important public building in South Pasadena for most of the 1900s. (Courtesy South Pasadena Public Library.)

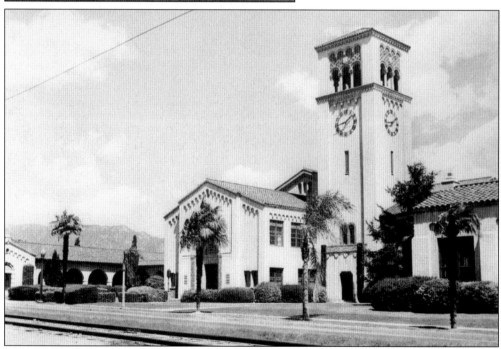

SOUTH PASADENA JUNIOR HIGH SCHOOL, 1928. This wonderful Mediterranean-style building was designed by Marsh, Smith, and Powell. The distinctive clock tower remains a South Pasadena landmark. (Courtesy South Pasadena Public Library.)

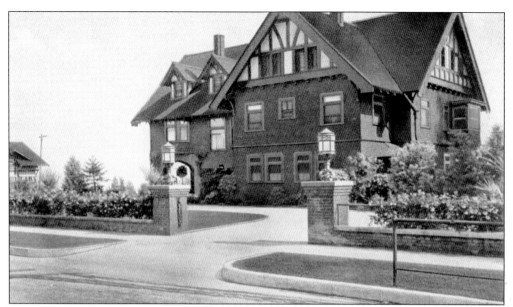

CHILDS TORRANCE RESIDENCE. This postcard shows the home much the way it appears today. The extensive gardens are gone from years of subdivisions and the building of the Arroyo Seco Parkway.

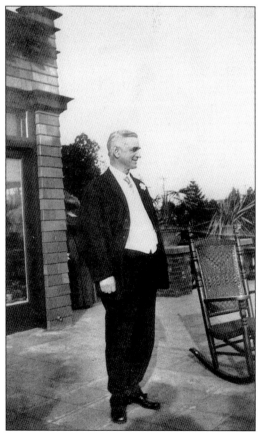

JARED SIDNEY TORRANCE, 1914. The founder of the city of Torrance was known as Sidney to his many friends. At the age of 59, he purchased the Rancho Dominguez grazing lands to fulfill his dream of "creating a city in which industry, commerce and residential interests would live together in harmony." Torrance never lived in Torrance. He lived on Buena Vista Street in South Pasadena. (Courtesy Torrance Historical Society.)

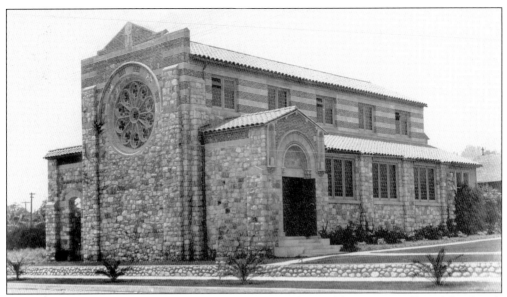

ST. JAMES'S EPISCOPAL CHURCH, 1907. A gift from Caroline Dobbins in 1924 allowed the church to build a bell tower. Former South Pasadena residents Florence Lowe Barnes and Thaddeus Lowe donated the chimes for the tower.

FLORENCE LOWE ("PANCHO") BARNES. Pancho Barnes set a world's speed record for women flyers for a one-mile course in 18.35 seconds. Barnes was a nationally renowned barnstorming aviatrix of her day.

P. G. Gates. Retired lumberman P. G. Gates owned a magnificent Craftsman mansion on Monterey Road. He donated the chemical laboratory building at the California Institute of Technology (Cal Tech) in Pasadena. The facility is known today as the Gates-Parsons Chemistry Laboratory.

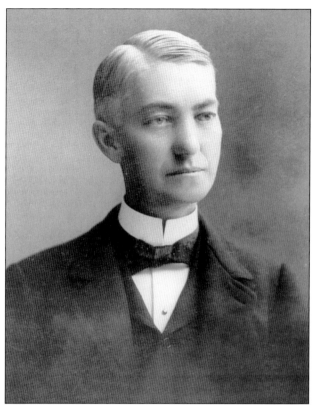

Gates Place, 1907. The five Gates brothers and their families built homes at Monterey Road and Indiana Avenue. The P. G. Gates mansion, shown in this photograph, was demolished along with the Don Gates home (not shown) to make room for a townhouse complex. The stone wall bordering the street was removed to widen Monterey Road in the early 1970s.

CHERYL WALKER, 1938. Former South Pasadena High School student Cheryl Walker won the 1938 Tournament of Roses pageant. Rose Queen Cheryl Walker (center) was immediately signed to a Hollywood film contract, leading to her most substantial role as the lead in *Stage Door Canteen* (1943).

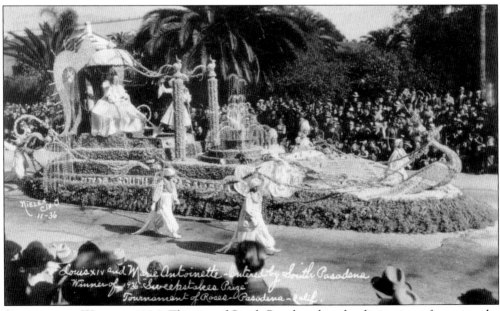

SWEEPSTAKES WINNER, 1936. The city of South Pasadena has the distinction of creating the oldest self-built float in the history of the Tournament of Roses parade.

HENRY DREYFUSS, 1951. Famous industrial designer Henry Dreyfuss made South Pasadena his home and built his West Coast design studio here. Dreyfuss designed a variety of products ranging from telephones to streamline trains. He was well-known locally as an early freeway fighter. With his wife, Doris Marks, in failing health due to liver cancer, he ended his life with her at their South Pasadena home on October 5, 1972. Both succumbed from exhaust fumes in their garage.

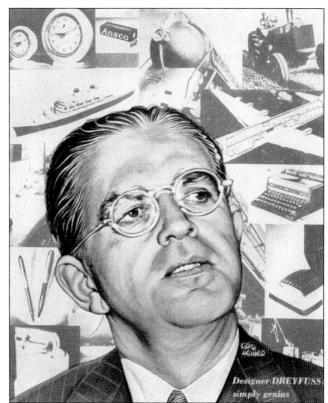

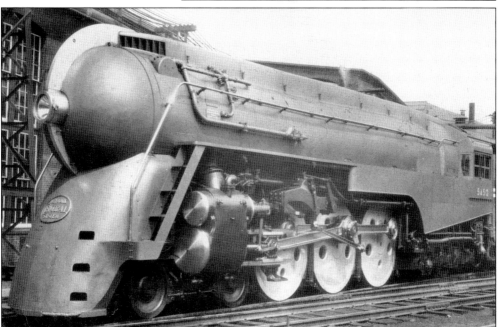

THE 20TH CENTURY LIMITED. This train is considered by many to be the best designed locomotive ever built. Dreyfuss was responsible for controlling every element of its design. (Courtesy Mike Schafer Collection, photograph by Ed Nowak.)

NELBERT CHOUINARD. Nelbert Chouinard was founder of the Chouinard Art Institute of Los Angeles. She was an art teacher who believed that students should gain basic skills in drawing and design and then follow their own leanings. Chouinard lived in South Pasadena for most of her life. During that time, her art school flourished as one of the top-five art schools in the nation. (Courtesy David and Linda Tourje.)

FLAMING HEART, CHOUINARD ART CENTER IN SOUTH PASADENA, 2004. Chouinard's success is probably best measured by the success of her students. Many world-renowned sculptors, cartoonists, set designers, graphic artists, fashion designers, and other artists can cite the teachings of Chouinard as the basis of their later artistic and professional accomplishments.

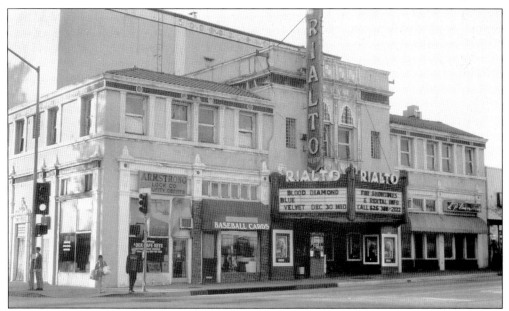

THE RIALTO THEATER. The Rialto Theater was built in 1925 and is one of the last remaining single-screen movie palaces in the Los Angeles area. The Rialto was added to the National Register of Historic Places in 1978, when it narrowly escaped the wrecking ball.

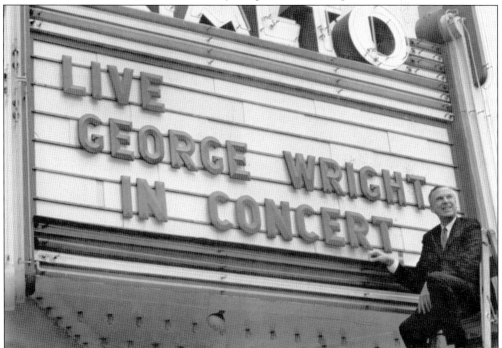

GEORGE WRIGHT LIVE AT THE RIALTO. World-famous organist George Wright had a dream. He wanted to play the mighty 2-manual, 10-rank Style 216 Wurlitzer at the Rialto Theater in South Pasadena. This is the same Wurlitzer pipe organ played by the great Ray Metcalf, known as Pasadena's finest organist, on opening night at the Rialto Theater on October 17, 1925. Wright's dream was fulfilled on a balmy September night in 1966 in South Pasadena.

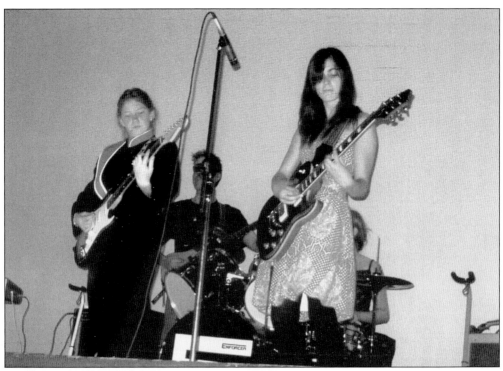

THE POWER OF DREAMS ROCKS ON! Young girl rockers take the stage at the Rialto Theater.

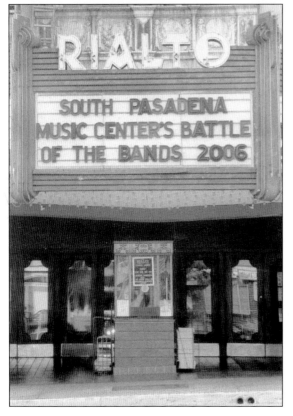

THE RIALTO MARQUEE. On this night, the music store next to the Rialto Theater sponsored a Battle of the Bands, adding to the long history of performances dating back to vaudeville in the 1920s. The Rialto Theater is South Pasadena's most beloved landmark and may soon be its centerpiece of historic restoration.

Eight
SMALL-TOWN CHARM, BIG-CITY HEART

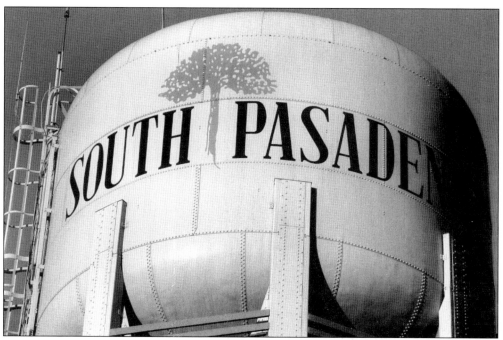

SOUTH PAS WATER TOWER. South Pasadena's vintage water tower, located at the top of Monterey Hills, is one of the city's most recognizable structures today. City water towers across America are finally being recognized for their historic value as important community landmarks.

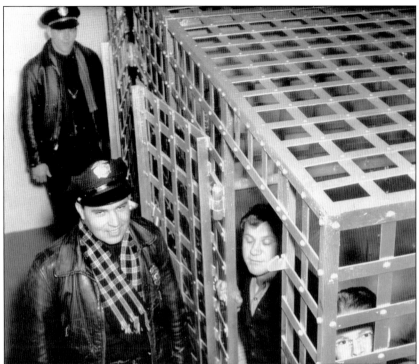

THE CITY JAIL, 1948. This holding cell is made of thick-gauge banded steel. Even the great Houdini would have a tough time getting out of this cage. (Courtesy South Pasadena Police Department.)

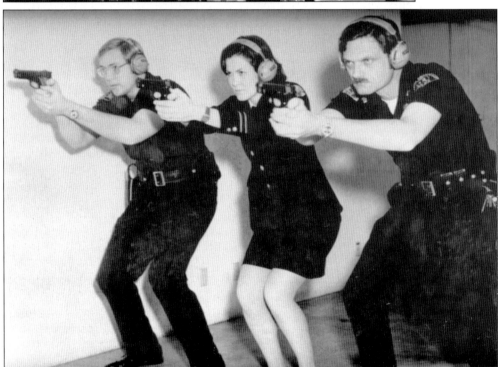

AT THE FIRING RANGE, 1970S. Qualifying with firearms, Los Angeles County supervisor Michael D. Antonovich (left) served in the South Pasadena Police Department Reserves for 32 years and is now retired. (Courtesy South Pasadena Police Department.)

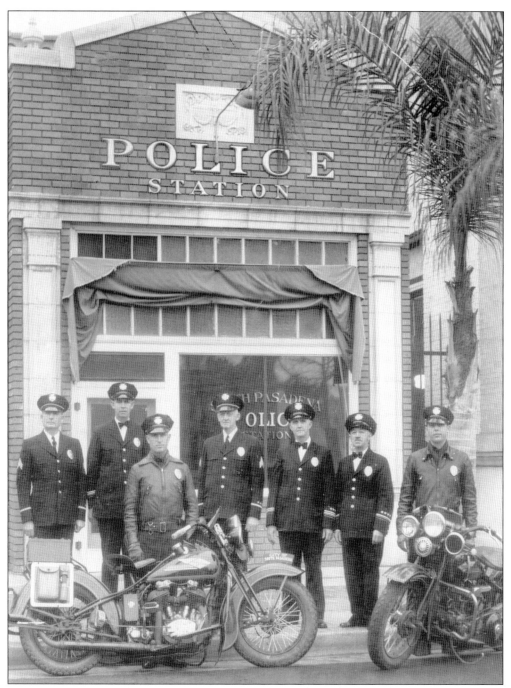

SOUTH PASADENA'S FINEST, 1933. South Pasadena's top brass stand with two leather-jacketed motorcycle cops in front of the police station on Mission Street next to the old city hall building, which is the current site of South Pasadena City Hall. In the street are two flat-head Harleys with bicycle-pedal kick-starters. (Courtesy South Pasadena Police Department.)

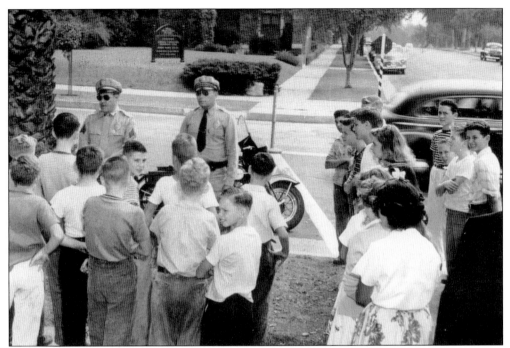

PEDESTRIAN SAFETY CLASS, 1950. The police department has been conducting pedestrian safety classes at schools and neighborhoods for more than 60 years. This shot was taken at the intersection of Oak Street and Fremont Avenue. (Courtesy South Pasadena Police Department.)

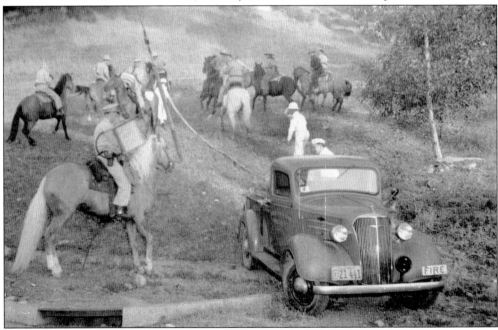

POLICE AND FIRE DEPARTMENT IN JOINT EXERCISES, 1945. The South Pasadena Police and Fire Departments practice putting down a hillside fire. Firemen on horseback are galloping up the hill pulling fire hoses from a 1937 Chevrolet pickup truck. The policeman on horseback with a holstered sidearm is holding a pump. (Courtesy South Pasadena Police Department.)

SOUTH PASADENA FIRE TRUCKS. The new fire engine (top) replaced the chemical engine (bottom) when the new city hall was built in 1914 at the corner of Mission Street and Mound Avenue.

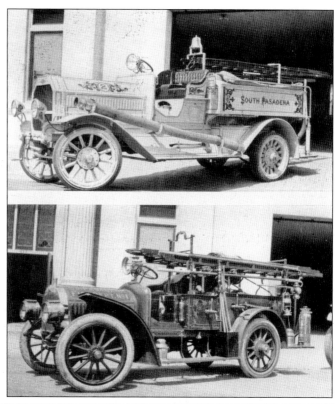

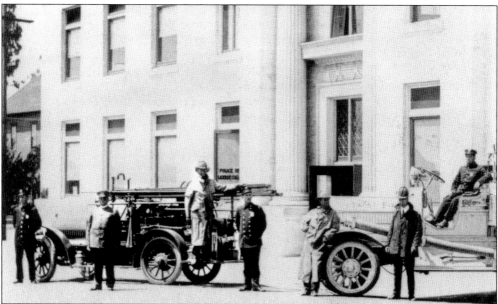

FIRE DEPARTMENT AT CITY HALL, 1914. Architect Norman Foote Marsh designed the two-story classic Revival building that housed the South Pasadena Fire Department. The building was modernized in 1949 and demolished to build the current city hall building. Fire trucks still exit at the fire department's garage on Mound Avenue today in exactly the same location they did almost 100 years ago.

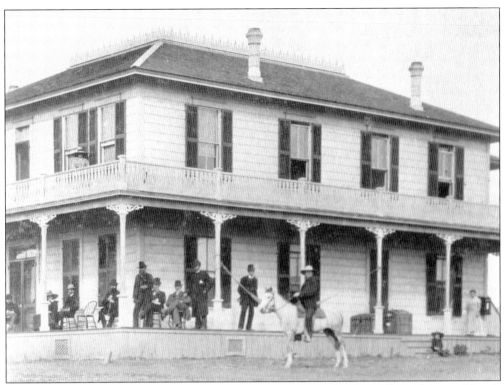

FIRST POST OFFICE IN THE HERMOSA VISTA HOTEL, 1882. Columbia Hill was the site of South Pasadena's first post office and hotel. In 1884, the post office was named South Pasadena, four years before the area was incorporated as a city. By 1898, the hotel had become a private residence. Owned by astronomer George Ellery Hale from 1906 until 1936, it was demolished in 1953 and subdivided into multiple home sites. (Courtesy Archives at the Pasadena Museum of History.)

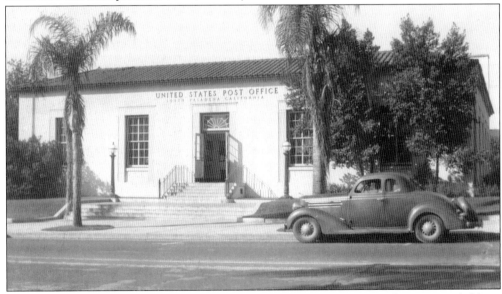

U.S. POST OFFICE, 1932. The post office on Fremont Avenue appears today very much like it did over 70 years ago.

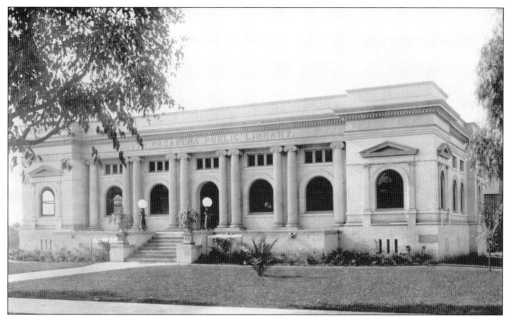

LIBRARY BUILDING, 1908. Andrew Carnegie gave $12,000 to cover the cost of building and providing oak furnishings for South Pasadena's first public library. The library was originally built on two lots at the southeast corner of Center Street and Diamond Avenue. The property later expanded to the entire block and was named Library Park.

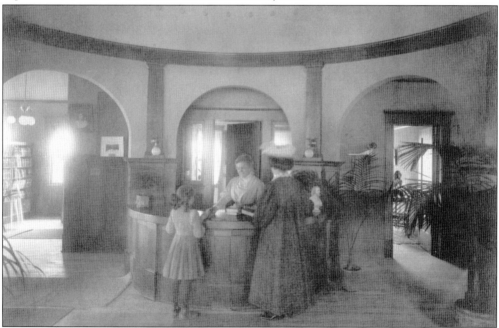

THE FIRST CITY LIBRARIAN. When Nellie Keith (center) retired in 1930, she had served as the city librarian for 35 years. That same year, the library was redesigned by Norman Foote Marsh and partners D. D. Smith and Herbert Powell, and it was rebuilt at the center of Library Park. The new main entrance to the library—now the community room—was located on El Centro Street and looks much the way it did 75 years ago. (Courtesy South Pasadena Public Library.)

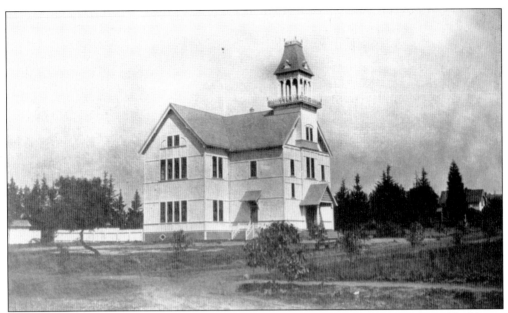

CENTER STREET SCHOOL, 1885. This early school site is across the street from the public library on El Centro Street. The street and school were renamed El Centro to avoid confusion with Pasadena's Center Street School. The school was rebuilt in 1928 by architects Marsh, Smith, and Powell. That same building serves as the school administration building today (see photograph below). (Courtesy South Pasadena Public Library.)

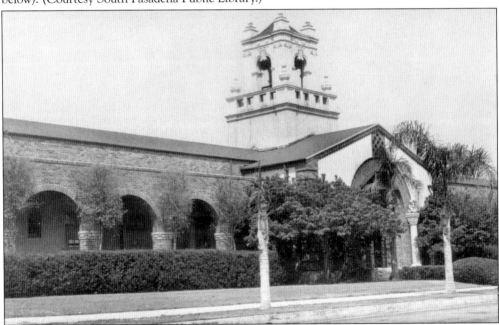

EL CENTRO SCHOOL (ADMINISTRATION BUILDING TODAY), 1937. This building was used as an elementary school as recently as 1979, when it became the administration building for the unified school district. The tower was removed in 1949 because of safety concerns. In 1952, the original quarter-ton school bell, cast in 1889, was mounted on the front lawn, where it can be seen today. This site has been important to South Pasadena education for over 120 years.

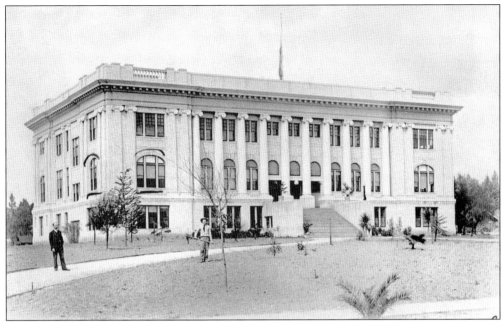

FIRST HIGH SCHOOL, 1907. The high school building above was finally constructed at an escalated cost of $75,000 due to the skyrocketing price of materials following the San Francisco earthquake disaster. In this photograph, construction has just been completed, the palms are planted, and lawn is seeded.

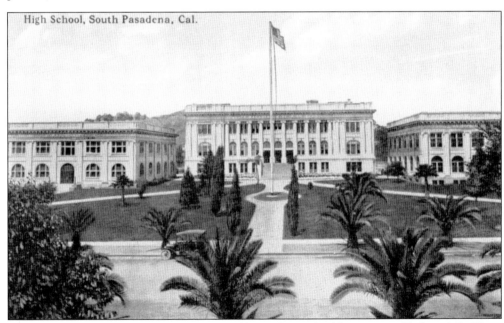

THE HIGH SCHOOL EXPANDS, 1915. Two additional wing buildings were added in 1912. These impressive neoclassic buildings were designed by architect Norman Foote Marsh. San Marino joined the South Pasadena High School District in 1921, staying for the next 30 years. The main buildings were declared unsafe, and all the core buildings were demolished by the early 1950s except for one relatively new auditorium built in April 1937.

COPA DE ORO, 1932. Students published the first yearbook in 1909 with a California poppy (and its golden cup, or *copa de oro*) on the cover. In 2009, the *Copa de Oro* celebrates its 100th year in publication, winning several national awards in the process. The journalism class published the first school newspaper, called the *Tiger*, in 1915. These two publications have earned a national reputation for high-quality student publishing for nearly a century.

HIGH SCHOOL GRADUATION, 1938. Before the main building was demolished, South Pasadena High School conducted extravagant graduation commencements on the school's front staircase and sweeping expanse of lawn. Floral arrangements for these lavish ceremonies were provided as a gift to the graduating class compliments of the Sato family nursery (see page 54). (*Copa de Oro*, 1938.)

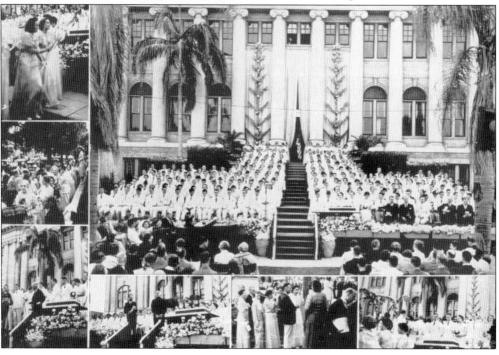

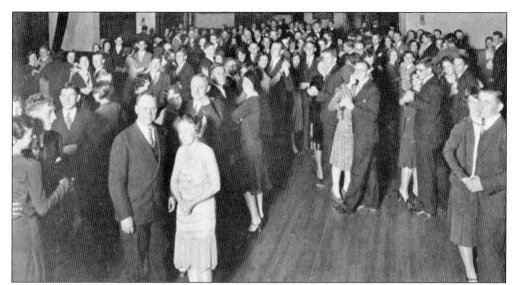

THE FIRST DANCE, 1928. The PTA-sponsored high school dance was so successful that it became a biannual event the follow year. According to the yearbook, they danced to Leighton Nobel's orchestra, and students "cast aside worry, teachers laughed long and loudly, busy mothers waltzed gaily, and staid fathers led all the girls onto the floor." (*Copa de Oro*, 1928.)

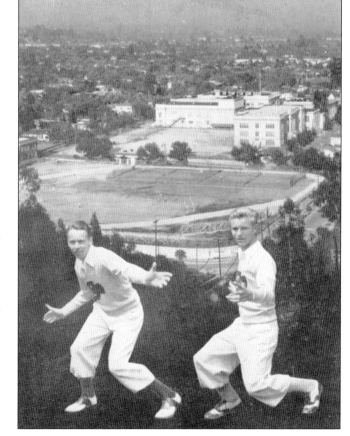

TWO WILD AND CRAZY GUYS, 1931. Behind these pep leaders is the high school athletic field, before the brick School Administration Building (far left) was demolished and replaced with a maintenance building, the gym, and basketball and tennis courts. Every high school building in this view has since been demolished. Only the staircase at the corner of Rollin Street and Diamond Avenue still exists. (*Copa de Oro*, 1931.)

COLOR DAY, 2006. Color Day is a South Pasadena High School tradition dating back before the 1950s. This one-day event is a favorite for students, giving them an opportunity to show their school pride by wearing anything (and everything) as long as it's orange and black. (Courtesy James Jontz.)

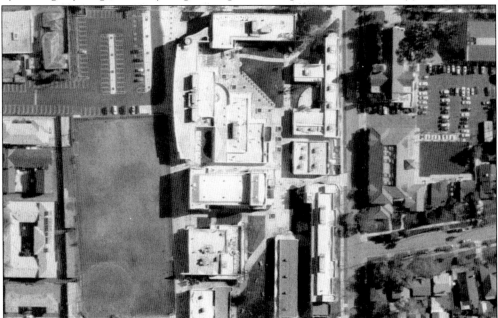

SOUTH PASADENA HIGH SCHOOL, 2005. South Pasadena High School (center) is pictured as it appears today. Notice the upper parking lot and sports field. This area was once a neighborhood before the South Pasadena Unified School District removed several homes and a city street for the high school expansion. Developers demolished the remaining homes along Lyndon Street to build apartments.

Nine
OUR TOWN

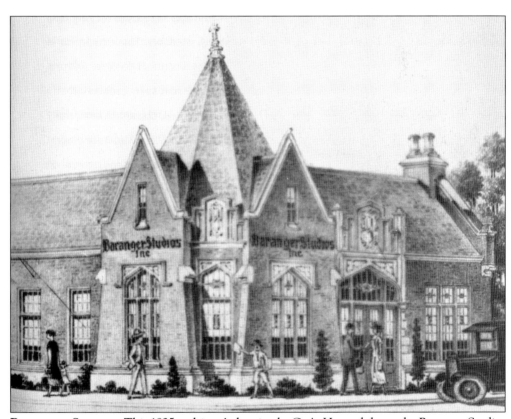

BARANGER STUDIOS. This 1925 architect's drawing by G. A. Howard shows the Baranger Studios very much as the building appears today on the corner of Mission Street and Orange Grove Avenue. The husband-and-wife team of Arch and Hazel Baranger was a successful manufacturer enterprise in South Pasadena for over 50 years, supplying motion displays to downtown jewelry stores. (Courtesy John A. Daniel.)

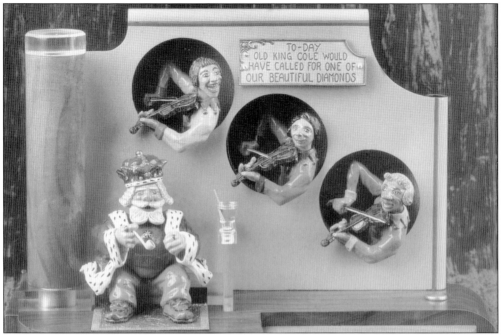

OLD KING COLE WITH HIS FIDDLERS THREE. This motion (M-119) shows the attention to detail and whimsical humor that was common with Baranger Studios display motions. Old King Cole with his Fiddlers Three enjoys a martini while his belly rolls with joy; the brass plate reads: "To-day Old King Cole would have called for one of our beautiful diamonds." The motions were created by Robert Gerlach and his chief assistant, Glen Orrell. (Courtesy John A. Daniel.)

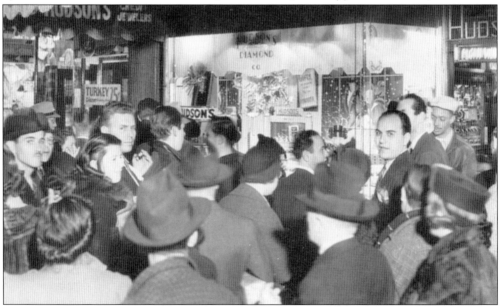

JEWELRY STORE ATTENTION GETTERS. The Baranger Studio motion displays were designed to literally stop traffic along busy downtown sidewalks. Motion displays were leased and recycled on a regular basis to freshen display windows, causing potential customers to take a look at some of the items for sale. (Courtesy John A. Daniel.)

THE WHAM-O SPORTSMAN. This slingshot was manufactured in South Pasadena by Wham-O. The Wham-O freestyle Frisbee also had historic roots here. The inventor of the modern-day freestyle Frisbee, "Steady" Ed Headrick, was born and grew up in South Pasadena. Headrick also invented the sport disc golf and personally installed Oak Grove Disc Park for the 1975 World Frisbee Championship. The nearby disc golf course was the first to use poles and baskets ("pole holes").

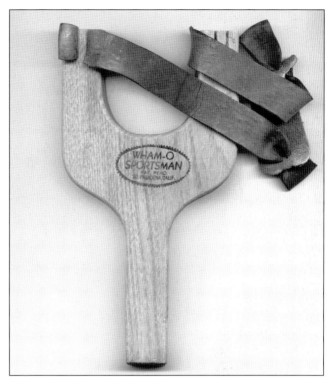

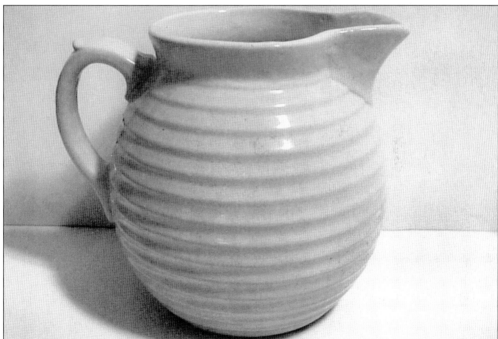

J. A. BAUER COMPANY (1885–1962). Bauerware was a colorful mix-and-match pottery tableware that has become one of the most sought-after lines of American pottery today. The J. A. Bauer residence and gardens were once located at Monterey Road and Fair Oaks Avenue in South Pasadena.

AILEEN'S PEANUT CRISP. This yummy treat came in a tin can and was a favorite snack item. Kids and adults alike would often smuggle pieces of peanut crisp rolled up in handkerchief into the Rialto Theater.

ASHTON'S SPECIAL BREAD "SPLIT-TOP LOAF." Located on Mission Street at the height of Route 66 and red car traffic, Ashton's Bakery boasted they were "the bakery that caused mother to stop baking."

OLD VIRGINIA DINNERS, 1942. This world-famous restaurant and local favorite was located on Pasadena Avenue, where the ostrich farm used to be. This sign was posted because waiters, cooks, and dishwashers were lured away from the kitchen to build ships, planes, and submarines for the war effort.

C. A. FOSSELMAN'S ICE CREAM. In this 1938 newspaper advertisement, Fosselman's proclaims that ice cream is the King of Foods (in small print it also reads "The Nation's Health Food"). Fosselman's ice-cream store was a favorite after-school hangout. Everyone in South Pasadena was sad on the day Fosselman's was forced to leave town when the building at the corner of Fair Oaks Avenue and Mission Street was scheduled to be demolished.

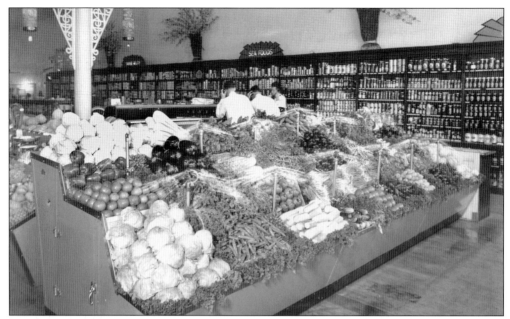

THE MODEL GROCERY COMPANY, 1930S. Located on 1022 Mission Street, Model Grocery Company boasted they were "one of the finest Grocery establishments in the United States." They could literally deliver on this bold statement since their delivery service was second to none. (Courtesy Archives at the Pasadena Museum of History.)

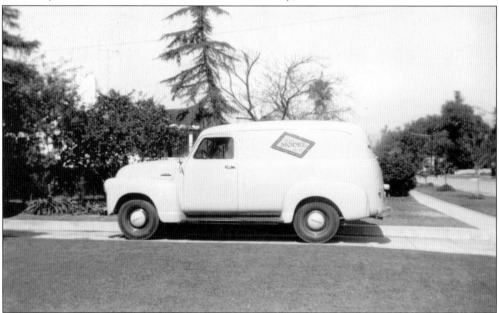

MODEL GROCERY DELIVERY SERVICE. A major portion of Model Grocery Company business was home delivery. They were one of the first businesses to successfully exploit the growing importance of the automobile in everyday home activities. Soon to follow were drive-through markets, drive-in movies, and drive-through fast-food restaurants. Automobiles and light delivery vehicles quickly built a reputation for fast, convenient, personalized service. (Courtesy Archives at the Pasadena Museum of History.)

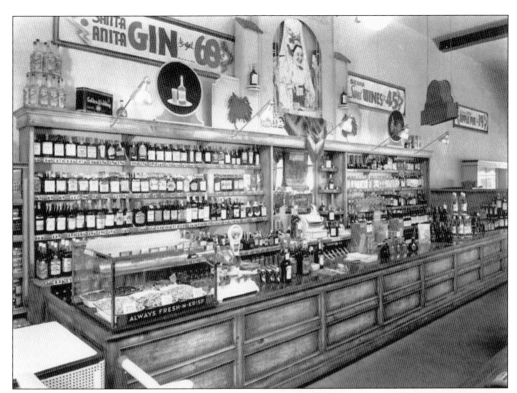

A&P MARKET, 1933. This interior view of South Pasadena's A&P neighborhood market shows the counter and shelves lined with bottles of liquor. Price-leader banner items included 69¢ gin, 45¢ wine, and a slice of apple pie for 19¢. (Courtesy California State Library.)

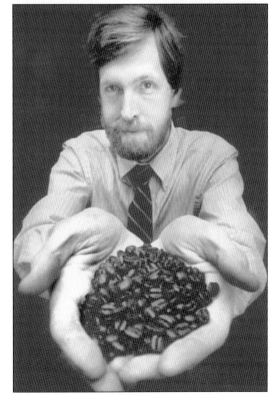

TRADER JOE'S. Doug Rauch, a coffee buyer for Trader Joe's in South Pasadena, shows his hands filled with coffee beans. Originally called Pronto Markets in 1958, the original Trader Joe founder Joe Coulombe changed the business model and name to reflect a South Seas atmosphere specializing in a variety of high-quality, hard-to-find products. For over 30 years, Trader Joe's corporate offices were located in South Pasadena. (Courtesy Los Angeles Public Library.)

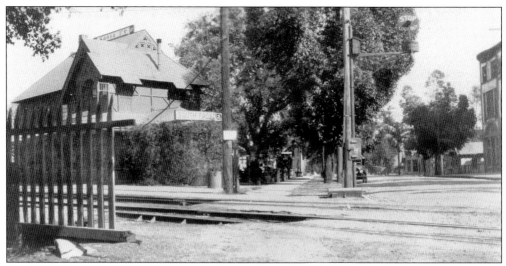

SANTA FE DEPOT, 1910. This view of El Centro Street at the Santa Fe Depot (left) shows the partial view of the Graham and Mohr Opera House Building (right). The opera building was an early home to a variety of businesses, including the Minier Gas Heater Company, and community activities such as the city's first free reading room. The opera building was razed in 1939. Despite efforts by Save Our Station (SOS), the Santa Fe Depot (built in 1887) was demolished in 1954.

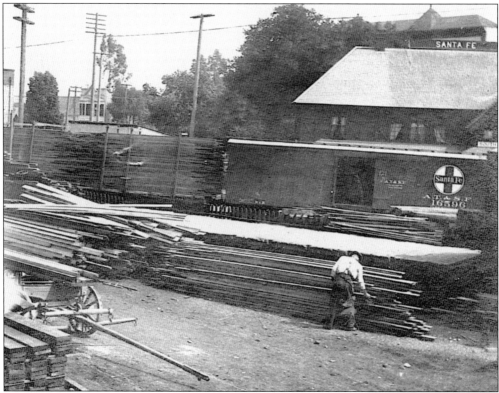

SANTA FE DEPOT/SOUTH PASADENA LUMBER COMPANY, 1909. The Santa Fe train stops at the station as lumberyard employees offload lumber directly onto their property. (Courtesy Melinda Rathbun.)

SOUTH PASADENA LUMBER COMPANY, 1909. Having a lumber company in the heart of South Pasadena, along with the nearby Rust Nursery, was extremely important to the city's early development. The lumber company was located on Mission Street near where the Mission Tile West is today. (Courtesy Melinda Rathbun.)

NEIGHBORHOOD DELIVERY, 1909. Mason H. Parsons rides the company horse-drawn wagon into the predominantly Craftsman South Pasadena neighborhood to make a home delivery. (Courtesy Melinda Rathbun.)

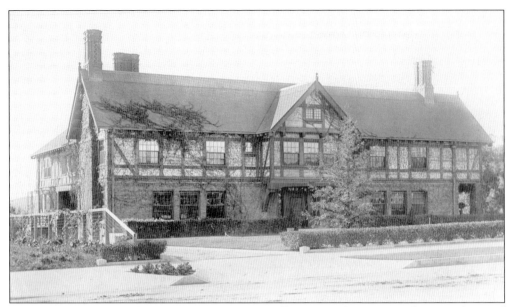

OAKLAWN MANSION. This magnificent mansion still exists in the Green and Green–designed neighborhood named Oaklawn. Near the site of the Raymond Hotel, this plot of land was originally orange groves except for one oak tree. Charles and Henry Green designed the neighborhood around the oak (since removed) and framed it visually with a cobblestone gateway entrance known today as the Oaklawn Portals (listed on the National Register of Historic Places).

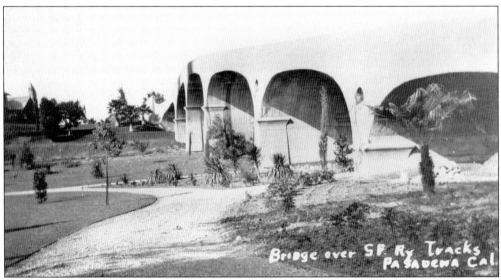

OAKLAWN BRIDGE, 1906. This reinforced concrete bridge recently had the center support removed to restore the bridge to its original design. This unique bridge was envisioned to cross over the railroad tracks, providing an impressive connection span from Oaklawn to Fair Oaks Avenue. Notice the black strip in the middle of the bridge. This was caused by the early steamers belching smoke from their stacks and is still visible under the bridge today.

ALTOS DE MONTEREY (MONTEREY HILLS), 1962. This billboard located at Via del Rey was part of the Monterey Hills Redevelopment Project. This was the last major city redevelopment project authority in South Pasadena. All subsequent downtown redevelopment projects have failed to get off the ground for the last 40 years. (Courtesy South Pasadena Public Library.)

MONTEREY HILLS, 1962. This view taken from La Manzanita shows the hills after they were graded and the streets paved. Home site lots sold for $20,000. On the horizon (just to the right of the S curve) is the future site of Monterey Hills Elementary School. In 1906, a city booster slogan read "South Pasadena 'The City of Happy Homes'." South Pasadena has always prided itself on being a predominantly neighborhood community. (Courtesy South Pasadena Public Library.)

THE BISSELL HOUSE (1887). This lovely Victorian mansion was the original home of Anna May Bissell, who was heir to the Bissell Manufacturing Company. In the formal dining room, appropriately placed, is a 100-year-old Bissell carpet sweeper. Many of the most prominent and influential guests have dined at the Bissell House, including one very special evening with Albert Einstein. The mansion today is a quaint yet upscale bed-and-breakfast establishment.

THE ARTISTS' INN. When C. R. Johnson settled in South Pasadena in 1895, he built a charming home for his family in the midwestern Victorian style of his native Indiana. The home was once situated on the family's egg and poultry farm. Today the garden home is a delightful bed-and-breakfast inn and cottage.

Ten

South Pas at Nightfall

The Walking Man. He seems to come out of nowhere with a stride that he means business. This banded statue can be seen in perfect forward motion at the Metro Gold Line Station.

SOUTH PASADENA'S FIRST BANK. Edwin Cawston was the bank vice president and made the first deposit of proceeds from his ostrich farm in 1904. The original bank vault is behind the counter in Kaldi's Coffee and Tea.

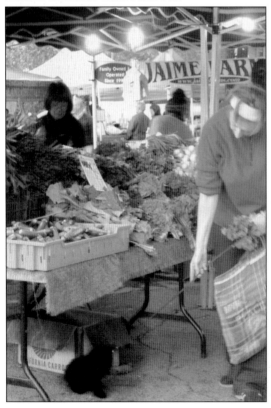

FARMERS MARKET AND HISTORY MUSEUM. The Farmers Market on Meridian Avenue is open Thursday evenings year-round with a variety of fresh produce, baked goods, and specialty food items. South Pasadena's history museum, the Meridian Iron Works, welcomes curious visitors while the market is open.

BUSTERS COFFEE SHOP. Where the light rail cuts diagonally across Mission Street is a variety of fun boutique businesses, including antique shops, art galleries, coffee shops, and restaurants. Mission Street was the original business district in South Pasadena. As transportation corridors opened with population growth in neighboring communities, the business district moved to Fair Oaks Avenue. Spurred on by the nearby Meridian Metro Gold Line Station, area businesses are no longer singing the blues.

METRO GOLD LINE. This incoming light-rail commuter stops in South Pasadena at the Meridian Station, near where the Sante Fe station stood over 100 years ago. Today the light-rail serves commuter passengers and welcomes visitors to South Pasadena to enjoy our small-town hospitality.

THE FREMONT CENTRE THEATER. Husband-and-wife team James and Lissa Reynolds have brought professional live theater back to South Pasadena. One critic described the theater as "one of the best kept secrets in San Gabriel Valley . . . fast developing a remarkable reputation for quality performances and thought-provoking topics."

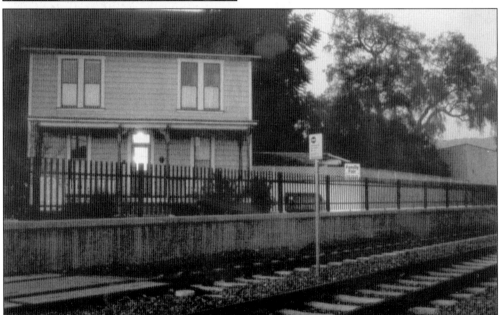

CENTURY HOUSE. This humble-looking house became known worldwide as the Myers House during the filming of the original *Halloween* movie in 1978. Today it is one of the most famous homes in cinematic history, along with the *Amityville* House and the *Psycho* House and Bates Motel at Universal Studios Hollywood. The Century House is located at 1000 Mission Street (at the tracks).

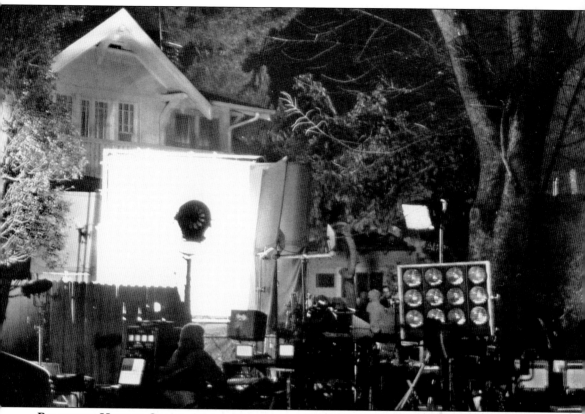

REMAKE OF HORROR CLASSIC MOVIE HALLOWEEN, 2007. Filming on location in South Pasadena has been a common occurrence for nearly a century. Many of the world's greatest filmmakers, actors, directors, writers, editors, set builders, and others in the industry have lived, worked, or attended school in South Pasadena. Some movies and television shows filmed in South Pasadena include: *Pollyanna*; *Ruggles of Red Gap*; 1970s television show *Family*; *The Wonder Years*; *Halloween*; *Beverly Hills 90210*; *NYPD Blue*; *Judging Amy*; *Seinfeld*; *The X-Files*; *That 70's Show*; *JAG*; *Boston Public*; *The Player*; *Scary Movie 2*; *Dr. Doolittle* (with Eddie Murphy); *The Terminator*; *Back to the Future*; *Desperate Housewives*; *Nip/Tuck*; *C.S.I.*; *Cold Case*; *Without a Trace*; *Space Jam*; *Beethoven 1 and 2*; *Father of the Bride*; *Honey, We Shrunk Ourselves*; *Liar Liar*; *Scream 2*; *American Pie 2*; *Jurassic Park 3*; *Old School*; *Bruce Almighty*; *Seabiscuit*; *13 Going on 30*; *National Treasure*; *In Her Shoes*; *Monster-In-Law*; *XXX*; *Herbie, the Love Bug*; *Pick of Destiny*; *Flags of Our Fathers*; and *License to Wed*.

THE ROCKY HORROR PICTURE SHOW. The Rialto Theater in South Pasadena boasts one of the country's longest runs of cult favorite *The Rocky Horror Picture Show*, starring Tim Curry as the transsexual from Transylvania. The Rocky Horror Players' regularly staged live acts before the film easily make it the longest continuously running live performance in California state history.

THE MUNCH COMPANY. A favorite sandwich shop in South Pasadena for more than a quarter century, the Munch Company is located on Mission Street.

FAIR OAKS PHARMACY. There has been a pharmacy on the corner of Fair Oaks Avenue and Mission Street since 1915. The familiar neon sign of the Fair Oaks Pharmacy helps to give the heavy traffic along Fair Oaks Avenue a bit of small-town charm.

GUS'S. Less than a block farther north, the neon sign for Gus's classic barbecue restaurant has made people hungry since 1949.

ONE HUNDRED THOUSAND ROSES. These roses await their final destiny as decoration for South Pasadena's Tournament of Roses parade float entry.

SOUTH PASADENA'S FLOAT. This view of South Pasadena's parade float was taken from the historic Oaklawn Bridge. The brightly lit pavilion takes on the appearance of a rock stage.

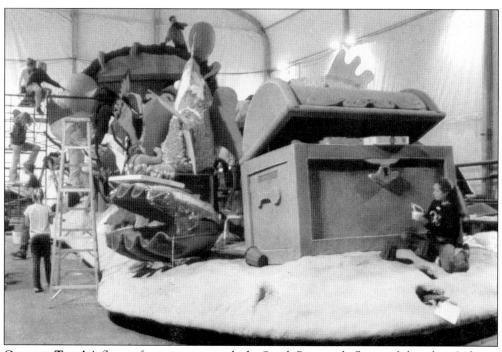

CRUNCH TIME! A flurry of activity surrounds the South Pas parade float with less than 24 hours before the judges arrive.

HOLY FAMILY CHURCH. These beautiful stained-glass windows can be seen from Rollin Street. St. Elizabeth Ann Seton (left) was the first native-born American to be canonized by the Catholic Church, and she established the first free Catholic school in America. The first American citizen to be elevated to sainthood, St. Frances Xavier Cabrini (right) founded the Missionary Sisters of the Sacred Heart and established nearly 70 orphanages, schools, and hospitals.

CATHEDRAL OAK MONUMENT SITE. False legend led to the building of this monument, where it was believed that Portola's dragoons carved a cross in a giant cathedral oak tree that once stood here and conducted California's first Easter service. Nevertheless, near the area where this monument stands today is the most historic place in South Pasadena: a Native American village, a natural spring, and the Garfias adobe.

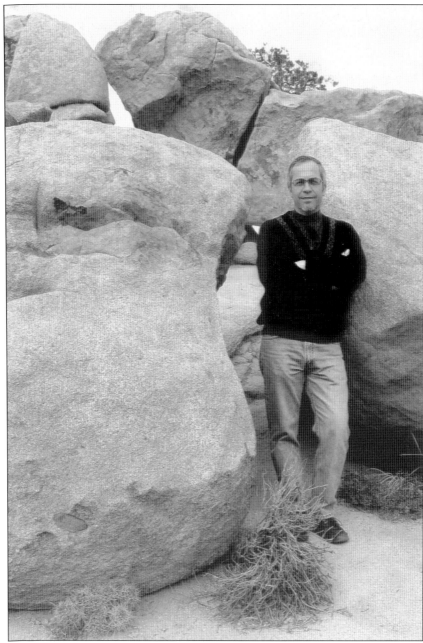

AUTHOR'S FINAL WORD: IT'S NOT EASY BEING SMALL. South Pasadena is a rarity among the communities that surround it. From the beginning, this small-town city has fought hard to maintain its independence from its larger city neighbors. The reason was admittedly selfish: to grow the best citizens, South Pasadena had to remain small. Together as one, we make certain that this unique place in time will not fade into history unremembered. This is because the ideals that keep South Pasadena small still live on in the hearts and deeds of it citizens today. The death of our city is as far away—or as near—as we wish to make it. For over a century, we have relied on the strength and perseverance of our elected officials and the fighters among us to protect our way of life. But we've always been in the fight together. After all, we are them. And they are us.

ACROSS AMERICA, PEOPLE ARE DISCOVERING
SOMETHING WONDERFUL. *THEIR HERITAGE*.

Arcadia Publishing is the leading local history publisher in the United States. With more than 3,000 titles in print and hundreds of new titles released every year, Arcadia has extensive specialized experience chronicling the history of communities and celebrating America's hidden stories, bringing to life the people, places, and events from the past. To discover the history of other communities across the nation, please visit:

www.arcadiapublishing.com

Customized search tools allow you to find regional history books about the town where you grew up, the cities where your friends and family live, the town where your parents met, or even that retirement spot you've been dreaming about.